GREEK AND ROMAN ART

T0018921

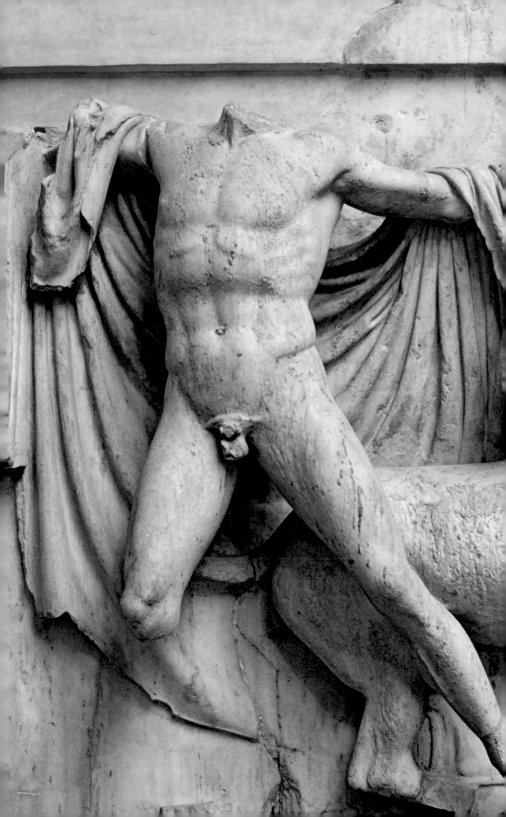

ART ESSENTIALS

GREEK AND ROMAN ART

—

SUSAN WOODFORD

—

CONTENTS

8 INTRODUCTION

10 STATUES IN STONE:
THE PERILS OF PROGRESS

24 STATUES IN BRONZE:
DISCOVERING NEW POSSIBILITIES

44 DECORATING ARCHITECTURE WITH SCULPTURE:
RECONCILING SHAPES AND STORIES

64 GREEK PAINTING:
CREATING A CONVINCING IMAGE

82 WIDENING HORIZONS:
INNOVATION AND RENOVATION IN LATER
GREEK SCULPTURE

98 PAINTING CAPTURES THE VISIBLE WORLD:
 FIGURES IN SPACE AND LIGHT

110 ROMAN SCULPTURE:
 ADOPTION AND ADAPTATION
 OF THE GREEK LEGACY

128 ROMAN PAINTING:
 USING THE INHERITANCE FOR DECORATION

144 UNITY AND DIVERSITY IN THE ART
 OF THE ROMAN EMPIRE

159 Glossary
166 Timeline
168 Written sources of information
171 Selected reading
172 Index
175 Acknowledgements

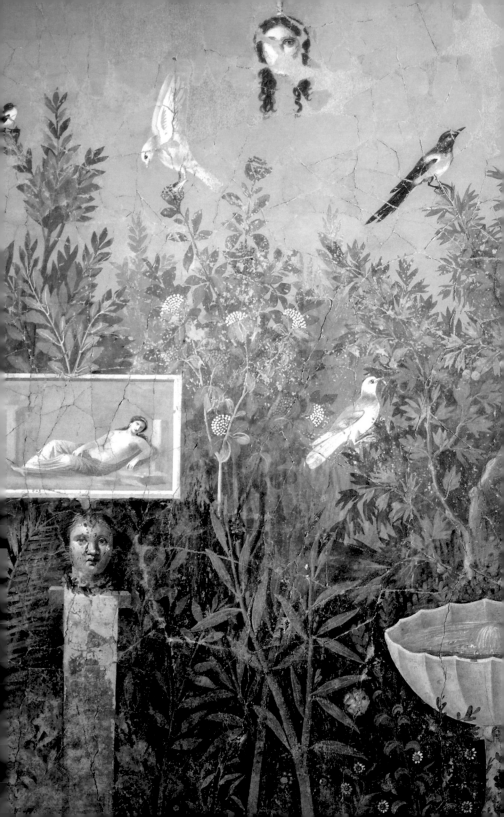

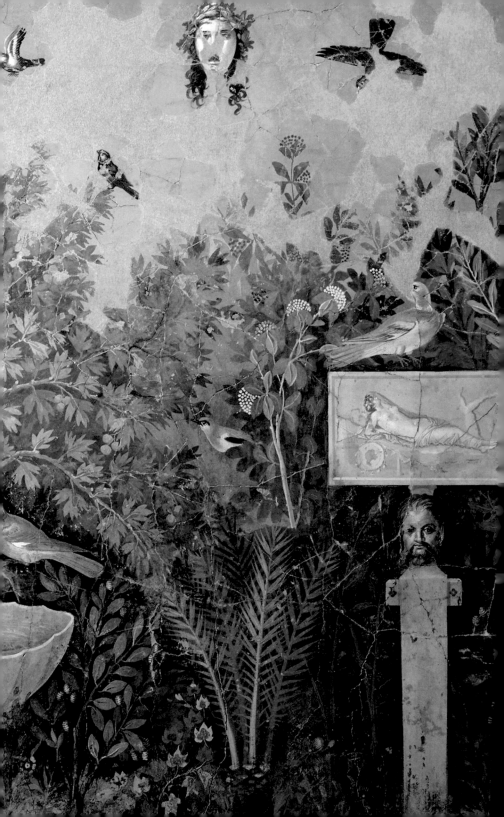

INTRODUCTION

While much honour and respect are lavished on the art of
classical antiquity, it is not always easy to understand what
all the fuss is about. Indeed, some Greek masterpieces
have survived to dazzle modern observers, but it is difficult
to see the point of many bleak old statues – some even
broken – and dull orange-brown bits of pottery. Yet these
depressing remnants of a once great art conceal the clues
that tell of heroic struggles and brilliant triumphs.

In antiquity, sculpture and painting were not mere
ornamental frivolities; they were fast moving enterprises,
part of an exciting society open to new ideas and
new techniques.

Sculpture was expensive. It had to serve some important
purpose. To work well it had to be handsome and
impressive, but also up to date. The same demands were
made of painting, whether on vases or walls, and though
it cost less, it still had to prove its worth in design and
execution. In Egypt, innovation was rare and little valued,
but in Greece things moved rapidly: appearances changed,
techniques improved, new goals were set and innovations

lauded. Successes were such that after a time, the Greeks did not hesitate even to revive and adapt their earlier works, thereby creating a new tradition of their own.

Although the Romans differed profoundly from the Greeks, they greatly admired Greek art and ideas. While constantly devising new forms of art for their own purposes, they also reworked previous creations (both their own and those of the Greeks) in adapting them to their different needs.

In later times, the art of the Greeks and the Romans in antiquity have continued to exert a great influence on artists. However, so much has been obscured by the ravages of time and war, that the story is no longer simple to follow, and a guide might help to take you through.

What follows is such a guide. Read now and learn of the creative daring of the Greeks and the intelligent adaptations made by the Romans and come to see with new eyes the developments that inspired later art.

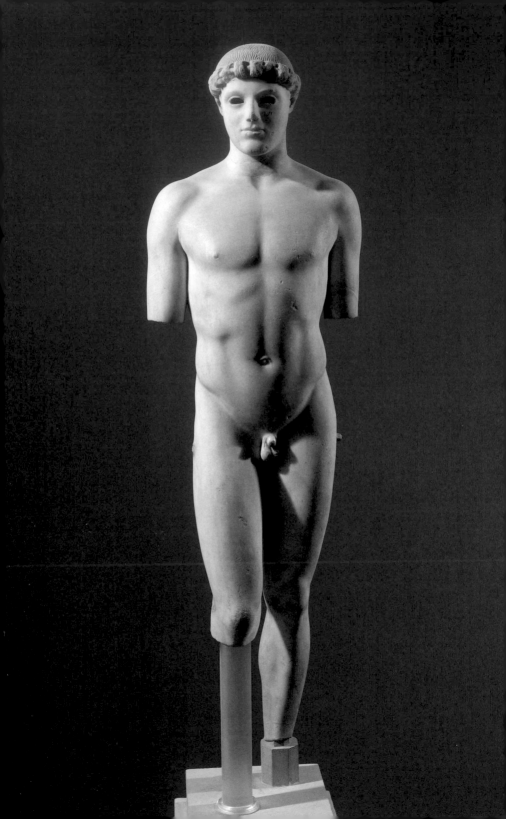

STATUES IN STONE: THE PERILS OF PROGRESS

-

The Greeks believed a statue should not only look like a man but should also be a beautiful object

-

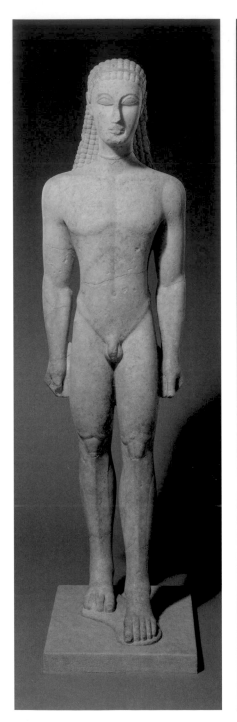

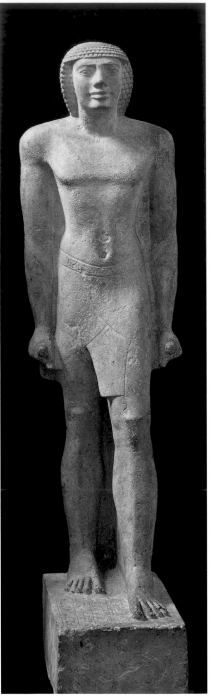

Opposite, left:
Greek youth (kouros)
c.590–580 BCE
Marble, height (without
plinth) 194.6 cm (76⅝ in.)
Metropolitan Museum
of Art, New York

Slightly over life-size,
this is one of the earliest
of the many marble
statues carved by the
Greeks in a pose that
remained conventional
for over a century.

From around 1250 BCE for some two hundred years, various disasters shook the lands around the Aegean Sea. Flourishing palaces were destroyed, sophisticated arts were lost, societies collapsed in ruin, lives fell apart. The land was devastated, depopulated and impoverished.

Under these unpromising conditions, about 1000 BCE Greeks settled down in small communities that eventually grew into city states and began to develop a civilization of their own.

GREEKS AND EGYPTIANS

Sometime after the middle of the seventh century BCE, the Greeks started to carve large-scale figures of youths out of marble (opposite, left). They must have been impressed by the statues made out of other hard stones that they had seen in Egypt, for the type of standing figure they made was clearly inspired by Egyptian models (opposite, right). There was also something else, even more important than inspiration, that came to them from Egypt: technique.

The Greeks adopted the Egyptian method of working

Opposite, right:
Egyptian figure
of Tjayasetimu
26th dynasty
(664–525 BCE)
Limestone, height
125 cm (49¼ in.)
British Museum, London

Whatever the size, the
Egyptians carved the
same type of figure
virtually unchanged over
centuries, regardless of
whether it was produced
on a reduced, over life-
size or gigantic scale.

Carving a life-size figure out of stone is not a simple matter and any unsystematic attempt quickly leads to disaster. The Greeks must have been aware of this, but they also knew that the Egyptians, many centuries earlier, had devised a reliable method for carving stone figures. The Egyptians would draw the outlines of the figures they wanted on the three (or four) faces of a stone block – front view on the front, profiles on the sides. Then they would chip away inwards gradually from the front and the sides, removing more and more stone until they reached the depth that corresponded to the figure that had been drawn (overleaf). The drawing had to be made according to a fixed scheme of proportions (for instance, one unit up to the ankle, six units up to the knee and so on) so that when the work was finished the front and side views would agree with one another.

The Greeks adopted the Egyptian method of working and, to a large extent, also the Egyptian system of proportions. That is why early Greek statues look so much like Egyptian ones (opposite).

The similarities in pose and technique are obvious; the differences in style and function are subtler, but just as

important. The Egyptian sculptor made a rather convincingly naturalistic figure of a man; the Greek statue is more abstract. Evidently, the Greeks believed that such a statue should not only look like a man but should also be a beautiful object in itself. They made it a thing of beauty by imposing three elements of design on the representation of the human form: symmetry, exact repetition of shapes and use of the same shape on different scales.

-

The Egyptian sculptor made a rather convincingly naturalistic figure of a man; the Greek statue is more abstract

-

The early Greek method of carving stone

Numerous unfinished statues have been found in Egypt with traces of just such a grid still left on them. They are thought to have been trial pieces made by young sculptors practising this method of carving.

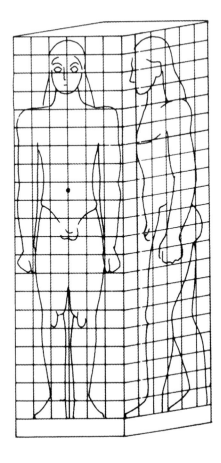

The sculptor avoided any pose containing twists, turns or bends since these would have spoiled the symmetry

The Greek sculptor, like his Egyptian counterpart, appreciated the natural symmetry of the human body with its pairs of eyes, ears, arms and legs, and stressed this symmetry by keeping the figure upright, facing straight forward, standing with its weight equally distributed on its two legs. He avoided any pose containing twists, turns or bends since these would have spoiled the symmetry.

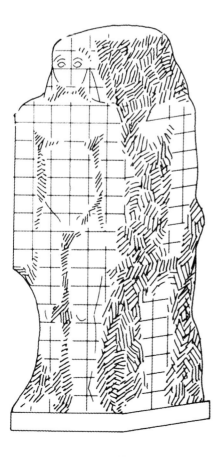
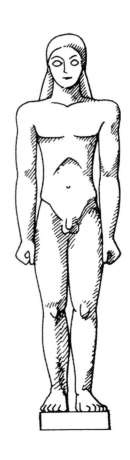

Symmetry about a vertical axis was thus easily achieved.
But symmetry about a horizontal axis was quite another matter.
The human form, with a single head at one end and a pair of legs at
the other, must have seemed unpromising material to organize in
this way. The Greek artist dealt with the problem by inventing his
own, rather limited, horizontal axes. He imagined a horizontal axis
running across the body at the level of the navel and then produced
a symmetrical design on either side of it – the upright V separating
the torso from the legs, and the balancing inverted V of the lower
boundary of the chest (opposite, red). He imagined another
horizontal line midway between the collar bones and the pectoral
muscles that run across the chest. He then balanced the shallow
W of the pectorals below with the inverted shallow W of the collar
bones above (opposite, blue). (The symmetry is easier to perceive
if you turn the book sideways.)

A great deal of thought about design has gone into the making of a figure

The sculptor repeated certain shapes exactly in order to produce
a decorative pattern. He made the line of the eyebrows follow
the line of the upper lids (opposite, brown) and made the hair
an assemblage of identical bead-like knobs, each the same as its
neighbours (opposite, brown). This is particularly effective from the
back, where the play of light and shadow on the richly carved hair
contrasts with the smooth surface of the body (page 19, left).

A third device the sculptor employed was to use the same shape
on different scales. Notice how the shallow W of the pectorals is
echoed on a smaller scale in the shallow Ws over the knee caps
(opposite, yellow) and how the protruding V of the torso-leg
division is echoed in the smaller, recessed, Vs of the elbows
(opposite, green).

A great deal of thought about design has gone into the making
of a figure that at first glance might appear rather more primitive
than the Egyptian statue (page 12, right). The Greek sculptor has
sacrificed the smooth naturalism of his Egyptian model for the sake
of creating a more aesthetically satisfying work. Greek artists were
always concerned with striking a balance between beautiful design
and natural appearance, though sometimes the balance was tipped
more towards the abstract, as here, and at other times more towards
the convincingly real.

**Greek youth
(see page 12 left)
c.590–580 BCE**

The simplicity of
the basic forms
of the straightforward
frontal statue is
elegantly enhanced
by the imposition
of symmetrical or
repetitious patterns
on the surface.

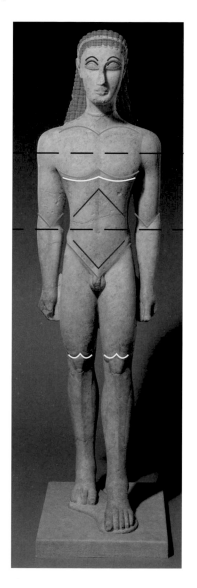

This statue was one of the earliest examples of a type that
was made over and over again for the next hundred years or so.
Such a statue could serve one of three functions: it could be a
representation of a god; it could be a fine object offered as a
dedication to a god; or it could be a memorial to a man, sometimes
placed on his tomb. There was nothing in any of these three
functions that prevented artists from modifying the form as
they saw fit.

THE BUMPY ROAD TOWARDS REALISM

Change for its own sake, or 'progress', seems to us the natural order of things, but in antiquity it seemed daring, usually undesirable, and often downright dangerous. Exact repetition of a model assured the sculptor of the successful outcome of his work. Changing even one element could lead to unlooked-for and often unfortunate consequences.

The Greeks, always adventurous and willing to take risks, found this out for themselves.

There were, of course, technical limitations on how much they could change at any one time, since the marble still had to be cut from the block in the same way and any statue had to be designed so that it would not fall over or break. Within these limits, however,

Youth from Anavyssos (kouros): front and back
c.530 BCE
Marble, height
194 cm (76⅜ in.)
National Archaeological Museum, Athens

Careful anatomical observations over two or three generations enabled an artist to produce this vibrant and energetic figure.

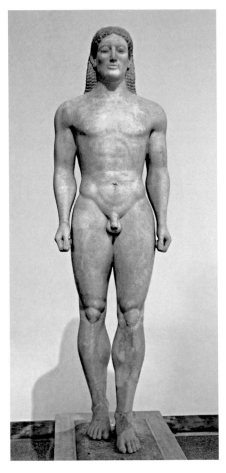
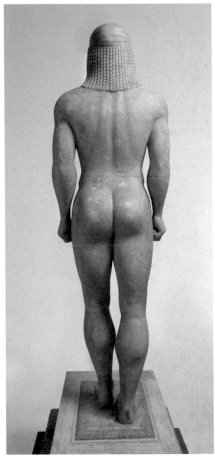

Below, left: Greek youth (see page 12, left), back

Below right:
Aristodikos (kouros)
510–500 BCE
Marble, height
198 cm (78 in.)
National Archaeological
Museum, Athens

It is unfortunate that the face of this delicately carved figure was accidentally smashed by the farmer who discovered the statue while ploughing.

Greek sculptors started to make changes and to produce, little by little, increasingly naturalistic images.

Within a hundred years, the statue found at Anavyssos (near Athens) had been created (opposite). This grave marker is a splendid figure, full of vibrant life, which shows a tremendous advance in the direction of naturalism. It is even more natural in appearance than the Egyptian statue (page 12, right).

But the new realism of the statue found at Anavyssos proved a mixed blessing. It was achieved by modifying the proportions of the figure and rounding anatomical features that had simply been engraved onto the surface before. But the hair – always difficult to render convincingly in stone – was carved much like that of the earlier statue. The stylized, decorative bead-like hair looked

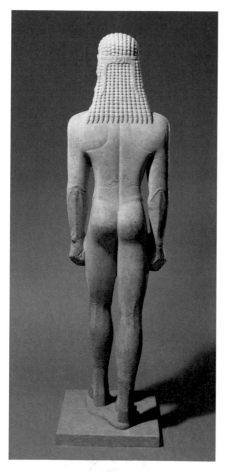

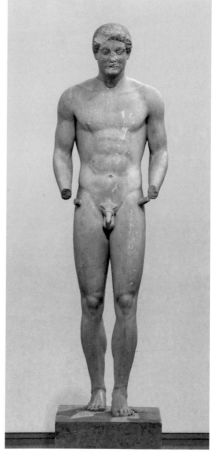

appropriate on the earlier statue because it fitted in with the whole stylized decorative character of the figure (pages 12, left, and 19, left). Not so on the later one (page 18). There the swelling, natural forms of the body clash with the artificial, stiff, bead-like hair. This sort of problem only emerges once artists start making changes.

The clash of styles could not have been foreseen by the sculptor. It simply emerged when he altered some of the traditional elements. How such unanticipated problems could take a sculptor by surprise can be seen from a third figure (page 19, right) made around 500 BCE, that is, about a generation after the last statue (page 18).

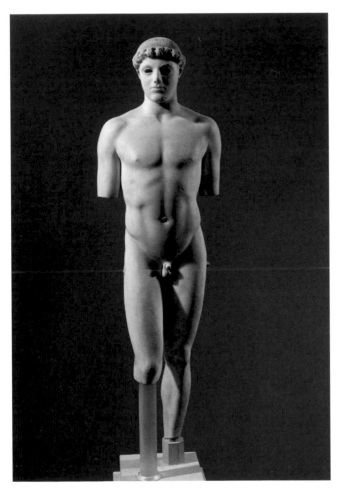

Kritios Boy
c.480 BCE
Marble, height
86 cm (33⅞ in.)
Acropolis Museum,
Athens

The revolutionary new pose used for this marble statue, with its suggestion of tranquil ease, contrasts with the apparent rigidity of earlier figures, which appeared to be standing with mechanical stiffness even when the carving of their anatomy became increasingly convincing in its details.

**Despite the convincing anatomical forms – or perhaps just because
of them – there seems to be something wrong with the statue**

This statue was also a grave monument, the monument of a
certain Aristodikos, and it is still more naturalistic (page 19, right).
It is so natural, in fact, that it makes the statue from Anavyssos look,
by contrast, almost like an inflated balloon. The problem with the
hair has been solved by a new fashion; the hair is tied up in plaits
(or braids) wound round the head rather than flowing loose down
the back. And yet, despite the convincing anatomical forms – or
perhaps just because of them – there seems to be something wrong
with the statue of Aristodikos. Why, one wonders, does he stand so
unnaturally? Why is he so stiff?

The pose is, of course, merely the consequence of the Greeks
having learned how to make statues from the Egyptians; this was the
pose that the drawings on the block produced. The outlines used for
this latest figure were basically no different from those used for the
earliest (page 12, left, for front view and page 19, left, for back view
and page 23 for a side view). In the earlier works, the pose presented
no problem; it was only when the figure has otherwise become so
natural that we begin to question it. A gain in one direction entailed
a loss in another.

**Each problem led to a solution on
a higher level of complexity**

The pattern that we recognize when we look at the three
figures – change, emergence of a problem, solution of that problem
and emergence of another – is a fundamental one for the whole
development of Greek art. And the failures are as important
to notice as the successes if we are to appreciate the daring of
the Greek artists. They could have endlessly repeated the same
proven formulae, as the Egyptians did, and run no risks, but their
restlessness and sense of adventure spurred them on from one
problem to another. Each problem led to a solution on a higher
level of complexity until finally the Greeks produced solutions that
carried such conviction that they left an impression on all later
western art and eventually reached the far corners of the world.

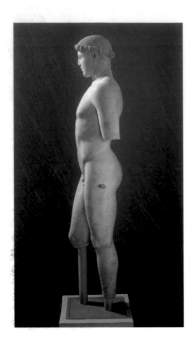

Kritios Boy (see page 20), left side
c.480 BCE
Marble, height
86 cm (33⅞ in.)
Acropolis Museum,
Athens

Placing the weight
on one leg, instead
of evenly distributed
between the two as in
earlier statues, allowed
the sculptor to give the
boy an appearance of
unselfconscious ease not
confined to the front
view but carried through
on all four sides.

AN UNEXPECTED SOLUTION

The new problem emerging from the accomplished naturalism
of the statue of Aristodikos (page 19, right), namely that the pose
began to look stiff and rigid, could only be solved in one way:
by changing the pose.

**The physical changes are actually rather small but the
consequences are enormous**

The sculptor who made the so-called 'Kritios Boy' (page 20
and above), shortly before 480 BCE, has done just that. Instead
of looking straight ahead, the boy turns his head slightly. Instead
of standing evenly on both legs, he has shifted his weight on to his back
leg, slightly raising the hip on that side.

The physical changes are actually rather small, but the
consequences are enormous. The statue has come to life.

The outlines drawn on the block for the earliest and the latest
of the three statues of youths (pages 12, 18 and 19, right) were
not fundamentally different, and sculptors could use the same basic
scheme, modifying only the proportions and details of finish,

Greek youth (see page 12, left), left side
c.590–580 BCE
Marble, height (without plinth)
194.6 cm (76⅝ in.)
Metropolitan Museum of Art, New York

Sculptors during this period initially carved their statues working systematically around the figure, gradually releasing the figure according to the drawings on the preliminary grid on all four sides. This resulted in the side views being as carefully finished as the front and the back and conveying the same sense of stability.

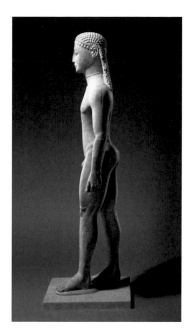

for over a century. The sculptor of the Kritios Boy, by contrast, had to make four radically new drawings (page 20 and opposite).

Nobody before had ever carved a statue in stone like this.

How could the sculptor be sure that the outlines would fit together properly in such a new and complex pose? How could he know that the statue would look right when it was finished?

It would actually have been much easier to experiment with a new pose if the statue were cast in bronze rather than carved out of marble.

KEY QUESTIONS

What are the advantages (or disadvantages) of using an established formula?

What are the advantages (or disadvantages) of breaking established rules?

Do you think it is an aesthetic improvement when sculptors change their techniques over time from surface decoration to carving musculature in three dimensions?

Are there methods, other than the Egyptian one, for carving statues out of stone?

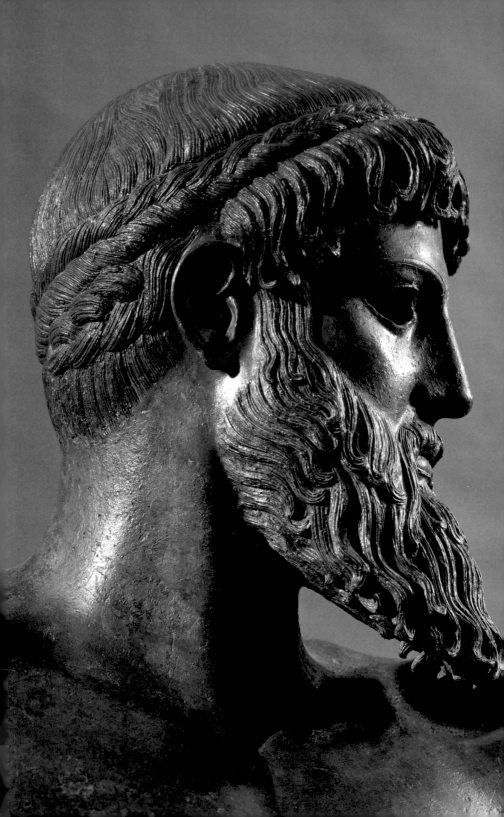

STATUES IN BRONZE: DISCOVERING NEW POSSIBILITIES

-

The tensile qualities of bronze allowed
sculptors to create statues in a previously
unimagined range of poses

-

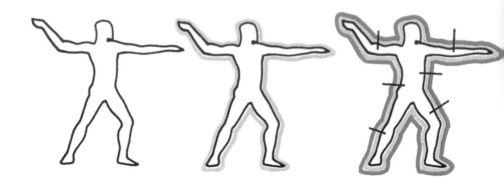

An artist would begin a bronze statue by making a model in clay, something he could easily adjust and modify as he went along (above, black). He could walk around the model as he worked and change it, rounding curves and adjusting contours, subtracting and even adding in a way that would be impossible for a sculptor carving marble. When the model was complete, the artist covered it with a thin, even coating of wax (above, yellow). The surface of the wax showed what the finished surface of the bronze statue would look like. Next, the artist surrounded the model with a mould (above, blue) made mostly out of clay, thick and strong enough to withstand the pressure of molten metal. The mould fitted neatly around the wax and was held firmly in place by metal rods pushed through to the core of the clay model. The wax was then melted out, leaving a gap between the clay model and the outer mould (opposite, above, white). Molten bronze (an alloy of copper and tin) was poured into the gap to fill the space originally occupied by the wax (opposite, above, orange). After the bronze had cooled and solidified, the mould was chipped away and the completed bronze figure was smoothed and finished. (The lost-wax method of bronze casting is often a great deal more complicated than this, as air vents are necessary and statues are seldom cast all in one piece, but this description and the diagram convey the essence of the process.)

A marble sculptor had to plan his work more carefully from the start. Mistakes were costly and hard to correct and it was best if he knew exactly what he was going to do before he began. He did not have the freedom of a sculptor working in bronze.

The Greek method of bronze casting

This simplified diagram explains the lost-wax method used to create hollow cast bronze figures on a large scale. Small statuettes could be solid cast, which would have been simpler, but this would have been too expensive for large figures.

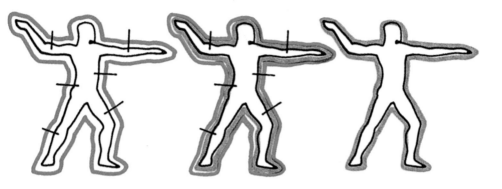

WAR AND THE FATE OF STATUES

In 480 BCE the Persians sacked Athens. This was part of the Persians' attempt to conquer Greece. The attempt failed and the very next year the Greeks defeated the invading Persians and drove them out of Greece.

The Athenians then returned to their devastated city and began to rebuild it. Many of the marble sculptures were beyond repair; the pieces were either used as building materials or simply buried. The Kritios Boy (page 20), the head severed from the body and the lower legs broken off, was buried, to be dug up by archaeologists only in the nineteenth century.

The Athenians then returned to their devastated city and began to rebuild it

Most bronze statues had either been carried off or melted down, but sometimes traces were left that revealed something about them. In fact, there is evidence that a bronze statue standing with the weight on one leg and the other relaxed, just like the Kritios Boy, had existed and must have been made shortly before the sack of Athens in 480 BCE.

It is easy enough to see how a statue like the Kritios Boy (pages 20 and 22) might have been created in *bronze*, but why should a sculptor try something so new and difficult in *marble*? Perhaps when

the marble sculptor saw how convincingly alive the bronze statue looked in the new relaxed pose, he became disappointed with his own traditional marble statue – even one as fine as the Aristodikos (page 19, right). Why was it so very lifelike and yet lacking the breath of life?

Every convincing new detail served only to make the statue look stiffer.

Why was it so very lifelike and yet lacking the breath of life?

Nothing but a change in pose could help. He decided to risk it, to make new drawings on his block. It would take almost a year of hard work before he would know if his attempt had succeeded. Perhaps he took the bronze statue as a model and as a guide for his drawings. Details from the Kritios Boy's head (below) suggest that the sculptor had been looking closely at a bronze statue.

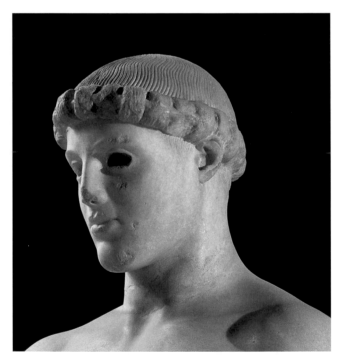

**Kritios Boy
(see page 20),
detail of head**
c.480 BCE
Marble, height of whole
statue 86 cm (33⅞ in.)
Acropolis Museum,
Athens

In antiquity the eyes of marble statues would normally be painted so that they did not have the blank stares we so often see in museums. It was rare, however, for marble statues to have eyes made of a different material (coloured glass or stone) inset, although this was usual for bronze statues.

**Even slight scratches show up clearly on the smooth,
shiny surface of a bronze**

For instance, the hair on the top of the head is represented by means of shallow scratched lines. This is characteristic of bronze technique, for even slight scratches show up clearly on the smooth, shiny surface of a bronze. Marble does not reflect light so sharply; on the contrary, it absorbs it so that much bolder carving is required to throw a shadow. This is why sculptors in the sixth century BCE represented hair by means of deeply cut, bead-like knobs (pages 12, left, and 18). The use of inset eyes is also typical of bronze work (below); eyes on marble statues were usually painted.

In the end, as we can see, this sculptor's attempt did succeed; we do not know how many others failed.

**Zeus of Artemisium
(see page 30),
detail of head**
c.460 BCE
Bronze, height of whole
statue 209 cm (82¼ in.)
National Archaeological
Museum, Athens

**The strong profile of
this Zeus conveys his
power and authority even
without the intensity of
the glance that would
once have emanated from
the inset coloured eyes.**

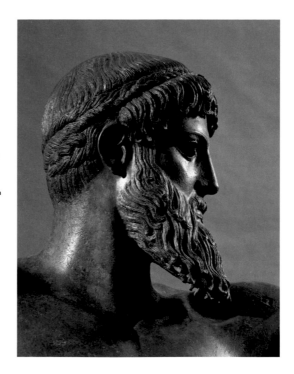

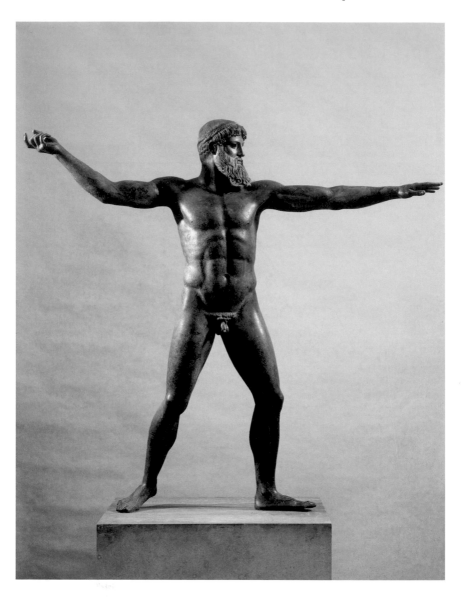

Zeus of Artemisium
c.460 BCE
Bronze, height
209 cm (82¼ in.)
National Archaeological
Museum, Athens

Symmetry is
systematically avoided
during this period as can
be seen in the way the
straight arm is contrasted
with the bent leg on one
side and the straight leg
the with bent arm on
the other.

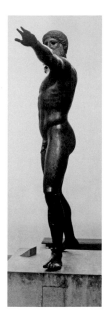

**Zeus of Artemisium
(see opposite), side view**
c.460 BCE
Bronze, height
209 cm (82¼ in.)
National Archaeological
Museum, Athens

**While the front view of
the god is magnificent,
seen from the side,
the eloquent pose of
the statue folds into
unintelligibility.**

GREATER BOLDNESS, NEW PROBLEMS

The Greeks, then, had created an entirely new kind of lifelike
statue. Nothing like it had ever been seen before. It made people
look at statues in quite a new way, apply new standards and ask new
questions, like 'What is this statue doing? Is he moving or is he still?'

Such questions probably never occurred to sculptors during the
sixth century BCE, but by the beginning of the fifth century they
had become vital issues.

**Artists of the early fifth century BCE were deeply
concerned about characterization**

The answer for the Kritios Boy (page 20) was clear; he stood
unambiguously at rest. Other sculptors sought to explore the
opposite extreme: emphatic movement. That is what the sculptor
of the bronze Zeus found in the sea off Cape Artemisium did
(opposite). The god is portrayed in the midst of vigorous action, at
the very moment of hurling a thunderbolt at an unseen enemy.

Questions of character and age were not asked when sculptors
carved youths in the previous century; in these respects, their
statues all looked much the same. By contrast, the artists of
the early fifth century BCE were deeply concerned about the
characterization of the men or gods they represented and used
every device in their power to differentiate them in terms of age
and personality. One has only to compare the youthful, tender head
of the Kritios Boy (page 28) with the magnificent, mature head
of the Zeus of Artemisium (page 29) to appreciate this. It is not
just a matter of adding a beard – sculptors in the sixth century BCE
would sometimes do that to indicate an older man. A profound and
thoughtful distinction has been drawn between early adolescence
and full maturity. (Both, of course, looked very much more
convincing when they still had their coloured eyes set in place.)

The expansive, open pose of the Zeus of Artemisium (opposite)
is possible because the tensile qualities of bronze allowed limbs
to be extended freely without supports in a way that would be
unimaginable in marble, where the heavy stone would be in danger
of breaking under its own weight. This is one of the reasons why
the greatest sculptors of the fifth century BCE preferred working
in bronze. And, as this statue shows, the quality of their work could
be outstanding.

But as we have seen, doing something new can easily unbalance the coherence of a work of art and unforeseen problems are likely to emerge.

The Kritios Boy (pages 20 and 22) and earlier statues (pages 12, left, 18 and 19) were easy to understand and appreciate from all four sides, but the Zeus of Artemisium, while splendid from the front and the back, is pathetically unintelligible from the side (page 31). This defect was an unexpected consequence of a great achievement.

Made at the same time as the Zeus of Artemisium (in the second quarter of the fifth century BCE), but very much more celebrated, was the Discus-thrower by the bronze caster Myron. It was so famous that centuries later the Romans ordered copies of it to be made. However, instead of having expensive bronzes

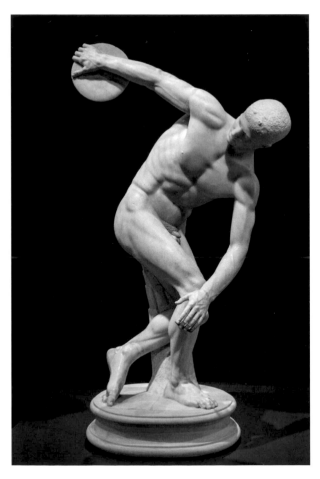

**Discus-thrower
(*Diskobolos*)**
Original by Myron in
bronze, c.450 BCE
Roman copy
Marble, height
125 cm (49¼ in.)
National Museum of
Rome, Palazzo Massimo
alle Terme, Rome

**The tension of a coiled
spring is masterfully
suggested in this famous
statue. It was popular
among the Romans who
often had it copied as a
freestanding statue and
also adapted it for use
in reliefs.**

cast, the Romans chose to have copies made of marble, which was cheaper (opposite).

Such a delicately poised statue in marble could not stand up without supports, and so a marble tree-trunk was placed behind the athlete to help support the top-heavy mass of stone and keep it from cracking at the ankles. Originally this would not have looked as disfiguring as it does now, since all marble statues were painted and the supporting tree-trunk would have been painted in so discreet a colour that it would hardly have been noticeable. The pupils of the eyes were painted too, which made statues look alive and responsive – the blank stares we meet in museums are the result of the disappearance of the paint with time. Hair was also painted, lips were tinted, clothing was decorated. We can get some impression of an

Statue in a garden
House of the Marine
Venus, c.70 CE
Roman wall painting,
height of pedestal
and statue
c.210 cm (82⅝ in.)
Pompeii, near Naples

**This Roman painting
of a marble statue used
as a garden ornament
shows what an important
difference the addition
of paint for details of
the face and clothing
would have made in
animating sculpture
made in antiquity.**

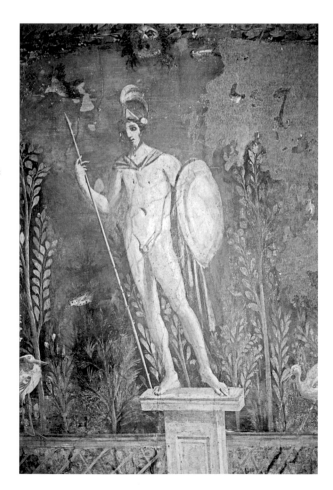

ancient marble statue with its original paint intact from a Pompeian painting of a statue in a garden (previous page).

The original bronze Discus-thrower by Myron has disappeared – most ancient bronzes were melted down at some time, either by accident or on purpose – so we are lucky to have the Roman copies. Although they do not convey the full beauty of the original, they give us important information about its design.

The discus-thrower is caught at the top of his backswing, just before he unwinds

The moment represented was chosen with genius. The discus-thrower is caught at the top of his backswing, just before he unwinds to throw the discus. It is an instant of stillness, and yet in our minds we are compelled to complete the action. But though the pose is momentary, there is nothing unstable about it.

The Greeks were concerned to make their statues not only resemble men but also to be objects of aesthetic delight. In the sixth century BCE, symmetry and the repetition of shapes were used to produce beautiful effects (page 17). These were now out of fashion. In fact, they were systematically rejected in the design

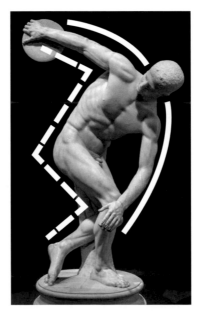

Discus-thrower (*Diskobolos*), design
Original by Myron in bronze, c.450 BCE
Roman copy
Marble, height
125 cm (49¼ in.)
National Museum of Rome, Palazzo Massimo alle Terme, Rome

of the Discus-thrower (opposite). Notice how consistently symmetry is avoided. The right side of the statue is dominated by the sweep of a continuous, almost unbroken curve (opposite, solid white), the left side by a jagged zig-zag (opposite, white dashes); the right side is closed, the left open; the right side is smooth, the left angular. The simplicity of the main forms – the great arc and the four straight lines meeting almost at right angles – brings harmony to the agitated figure. The torso is seen from the front and the legs from the side so that the most characteristic features of each are presented simultaneously. Both representation and design are marvellously clear.

Notice how consistently symmetry is avoided

**Discus-thrower
(*Diskobolos*), side view**
Original by Myron in
bronze, c.450 BCE
Roman copy
Marble, height
125 cm (49¼ in.)
National Museum of
Rome, Palazzo Massimo
alle Terme, Rome

But what of the problem that emerged from the active pose of the Zeus of Artemisium (page 30), the awkwardness of the side view (page 31)? Alas, it is still there, perhaps even in exaggerated form. The view from the side showing the chest and the legs each in their least characteristic aspects is so compressed that it is difficult to understand what the figure is actually doing; the action has become virtually unintelligible (below).

It was up to artists of the next generation (about 450–420 BCE) to tackle these problems.

THE CLASSIC SOLUTION

The classic solution was formulated by Polykleitos, a bronze caster from Argos. He made a statue of a man carrying a spear and wrote a book (now lost) explaining the principles on which it was based. He was much admired for having embodied the rules of art within a work of art. Unfortunately, neither book nor statue has survived. Once again, we have to try to deduce from Roman copies in marble what made the statue so celebrated (pages 36 and 37, left).

A great deal of art has gone into a statue that looks artless

The Spear-bearer is shown in the midst of a step; a momentary pause combines stability with a sense of potential movement. The action is less vigorous than that of the Discus-thrower and this

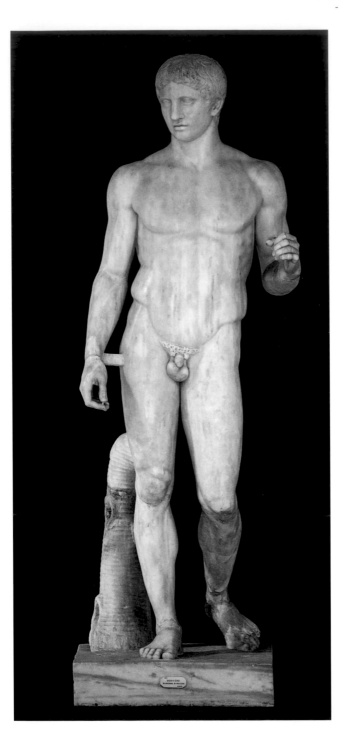

**Spear-bearer
(*Doryphoros*)**
Original by Polykleitos
in bronze, c.440 BCE
Roman copy
Marble, height
212 cm (83½ in.)
National Archaeological
Museum, Naples

The original bronze statue
undoubtedly would have
had greater subtlety
of form and would
have accentuated the
contrasting sides of the
torso. Much is lost in this
insensitive copy.

**Opposite, above:
Spear-bearer, left side**
Original in bronze,
c.440 BCE
Roman copy
Marble

**Opposite, below:
Spear-bearer, right side**
Original in bronze,
c.440 BCE
Roman copy
Marble

The side views, like the
front view, are relaxed
and composed, capturing
the feeling of a brief
pause in the midst of a
continuous movement.

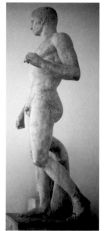

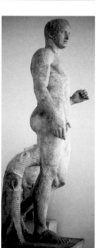

has helped Polykleitos solve the problem of the side views. Although the two sides have very different qualities, each is harmonious and lucid in itself.

The left side (left, above) is angular, the sharp bend of the arm responding to the sharp bend in the relaxed left leg. The right side (left, below), by contrast, is tranquil, with the verticality of the straight weight-bearing leg continued in the vertical relaxed arm. The turn of the head adds interest to this side, a point that was appreciated by a later sculptor making a relief (below), who adapted this view of the Spear-bearer for his own purposes.

In addition, Polykleitos has created something new with the torso of his figure. The Spear-bearer holds the spear in his left hand (to our right), so that his tensed left shoulder is slightly lifted but, at the same time, his left hip drops because the relaxed leg bears no weight. The consequence is that the left side of the torso is extended. On the right side, the weight-bearing leg makes the hip higher, while the shoulder of the relaxed arm is lower, and the right side of the torso between hip and armpit is contracted.

Right: Relief from Argos
4th century BCE
Marble, height
61 cm (24 in.)
National Archaeological
Museum, Athens

A sculptor in the following century cleverly adapted the side view of the Spear-bearer for his relief of a man with a horse.

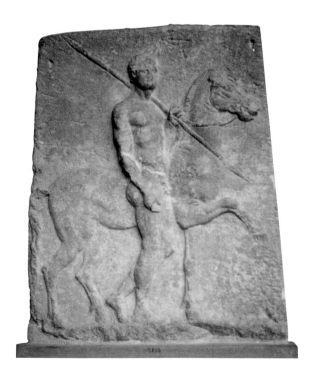

The diagonal opposition of tensed and relaxed limbs and the contrast of extended and contracted sides of the body creating a sense of organic responsiveness within the torso is called contrapposto. The device is used over and over again throughout the history of art, so effective is it in imparting a sense of organic balance, dynamic equilibrium and controlled vitality to figures made of stone or bronze or paint.

How different this is from the static balance of the sixth century BCE statues, whose right and left sides are essentially mirror-images of each other! This was a groundbreaking invention, something never seen before, but much appreciated ever after.

A great deal of art has gone into the making of a statue that looks artless. The perfect harmony attained in this work brought no new and unanticipated problems in its wake. It was the classic solution.

CHOICES OF STYLE AND TASTE

Though the Greeks in the sixth and fifth centuries BCE liked to portray men in the nude as they were often seen exercising in the gymnasium, decent women were never seen naked. Artists, therefore, preferred to show sculpted women clothed. The clothing actually worn by Greek women was loose and could be draped in a number of different ways according to the wearer's choice. Artists, too, had considerable freedom in choosing how they would depict drapery. Drapery in all periods has provided much scope for expression, enabling artists to suggest calm serenity or agitated movement in accordance with the mood of the scene portrayed and the taste of the times.

**At one time simplicity is highly valued;
at another, richness and elaboration are preferred**

Changes in taste often seem to have an inner rhythm of their own, almost independent of other factors. At one time simplicity is highly valued; at another, richness and elaboration are preferred. We see such changes in modern fashions. They also influenced ancient art.

Although a statue of a clothed woman may be entirely made of stone, some parts of it should look like a living person and other parts like inanimate, pliable fabric (see opposite and pages 40 and 43).

Opposite, left:
**Draped female figure
(Berlin Goddess)**
c.570 BCE
Marble, height
192.5 cm (75¾ in.)
Antikensammlung,
State Museums of Berlin,
Berlin

Sculptors were at
first baffled when
trying to find a way
to suggest a human
body existing beneath
concealing drapery.

Opposite, right:
**Draped female
figure (kore)**
c.520–510 BCE
Marble, height
55.3 cm (21¾ in.)
Acropolis Museum,
Athens

The lively expression
of the face and the
complex drapery succeed
in animating a basically
static figure.

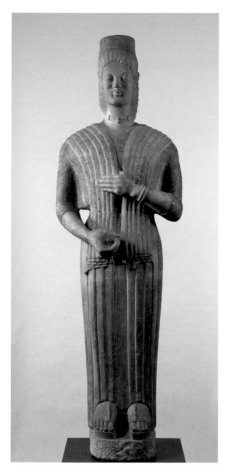 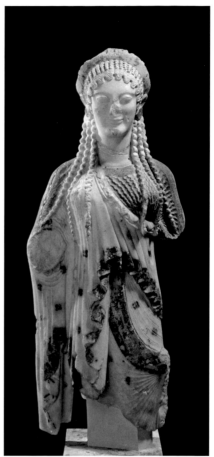

A sculptor in the second quarter of the sixth century BCE
(575–550 BCE) was able to impart a lifelike quality to the face,
arms and feet of his figure (above, left), but he left the clothing as
a sort of dead area, with nothing more than its orderly appearance
and some colourful decoration on the surface to recommend it.
The many parallel vertical folds carved into the stone neither
portray the soft natural fall of cloth nor suggest the presence
of a living woman's body beneath it.

Artists had made great progress by the last quarter of the sixth
century BCE (around 525 BCE). Sculptors could now suggest the
existence of a pair of swelling breasts, a slim waist, and a well-
rounded thigh beneath the elaborate play of folds (above, right).
They could even distinguish two different kinds of cloth: a soft

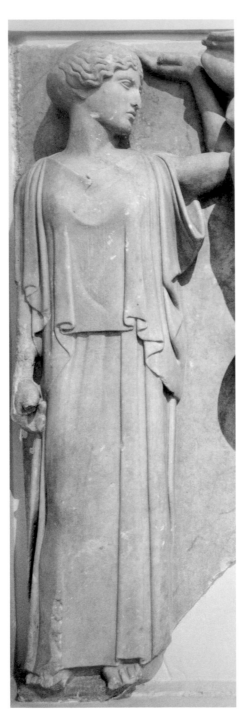

**Draped female
figure (Athena)**
From the Atlas metope
at Olympia, c.460 BCE
Marble, height
114 cm (44⅞ in.)
Archaeological Museum,
Olympia

**Despite the fact that the
drapery is nothing but a
piece of stone, it is made
to look like a heavy fabric
enveloping the body of
a real woman standing
at ease.**

crinkly undergarment (painted a darker colour) and a heavy woollen
cloak that is draped diagonally.

Sculptors could show draped female figures as living women wearing garments made of soft fabrics

By the first half of the fifth century BCE (around 460 BCE),
sculptors were able to make a statue look like a real woman wearing
clothing. Even a figure in relief shows how well body and drapery
are integrated and how naturally they are both treated (opposite).
Although little can be seen of the body, the unsymmetrical fall of
the vertical folds of the skirt and the slight displacement of the
material over the bosom convincingly suggest a body beneath.

By contrast, the artist who carved the so-called 'Venus Genetrix'
(known only through Roman copies; page 43) in the late fifth
century BCE has made the drapery so thin that the goddess's
body is revealed almost as completely as it would be in a nude
representation. In the original statue, paint would have made clear
what was draped and what was bare, revealing dramatically that only
one breast was actually uncovered.

Nature, design, fashion – all made demands on the sculptor

In less than two centuries, then, sculptors had developed
techniques and formulae that enabled them to show draped female
figures as living women wearing garments made of soft fabrics.
The progress in naturalistic representational skill is very marked.

So too are changes in taste. In the first half of the sixth century
BCE, drapery was austerely simple (page 39, left). By the end of
the century, it was shown as complicated and ornate, with strong
diagonal accents, a multitude of folds going in different directions
and a vivid suggestion of the body beneath (page 39, right). In the
early fifth century BCE, there is a reaction and a return to a more
severe style of drapery, one that covers and conceals, falling in
heavy vertical folds (opposite). By the end of the century, however,
something livelier was in demand (page 43). A strong diagonal
accent is again introduced in the drapery that slips off the shoulder
– in terms of design much like the cloak draped under the breast in
the statue depicted on page 39 (right) – and a number of lively folds

counteract the simple vertical fall of the fabric; now too the body is again revealed. These swings of taste are virtually independent of the continuous progress in naturalistic representation.

The factors that influenced the development of Greek art are many and complex

Nature, design, fashion – all made demands on the sculptor. The factors that influenced the development of Greek art are many and complex. It would be unfair to the artists and their achievements to simplify the situation in which they found themselves and the multitude of conditions they struggled so valiantly to satisfy.

KEY QUESTIONS

When is it more appropriate to make statues in marble rather than bronze?

Why is it more challenging for a sculptor to portray a figure whose weight is not equally distributed on both legs than one who stands in a more symmetrical pose?

How important is it that a statue of a draped figure should suggest the body beneath the clothing?

Can drapery convey emotion?

**Draped female figure
(Venus Genetrix)**
Greek original made
in marble, c.410 BCE
Roman copy
Marble, height
164 cm (64⅝ in.)
Louvre, Paris

**Sculptors gradually
succeeded in creating the
effect of drapery so thin
that the body virtually
appears to be visible
beneath it. In antiquity
the addition of colour
would have made it
clear that the figure was
not so naked as it may
now seem. It is worth
noting here that the
contrapposto, invented
by Polykleitos for a male
figure in action, has here
been cleverly applied to a
stationary woman, whose
animation only comes
from the action of lifting
her veil.**

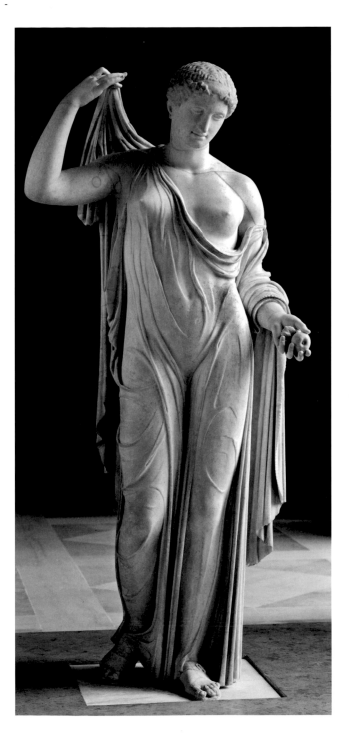

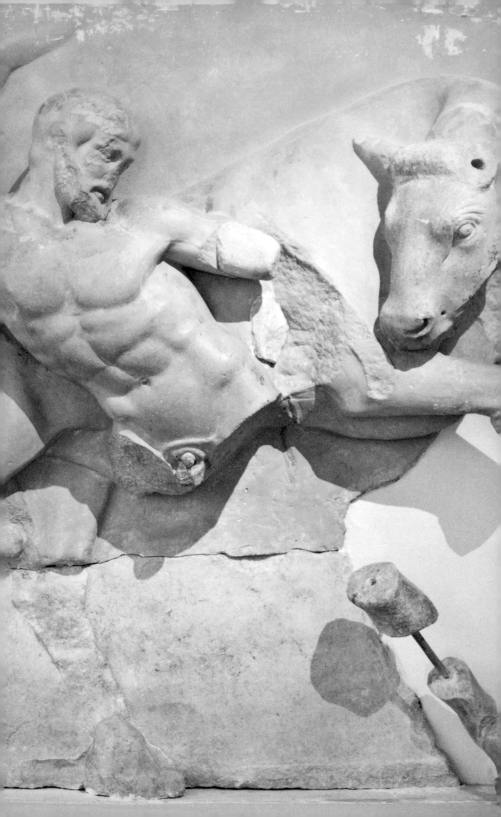

DECORATING ARCHITECTURE WITH SCULPTURE: RECONCILING SHAPES AND STORIES

-

**It is not easy to arrange figures
to fill an awkward space, tell a story
and tell it coherently**

-

Drawings with shaded areas indicating the positions of the pediment (opposite, above), metopes (opposite, below) and frieze (above).

The simple geometry of Greek architecture produced a stark beauty, but temples could seem coldly austere and forbidding if left undecorated. From early on, therefore, the Greeks often enlivened their buildings by adding sculpture.

The first requirement of such architectural sculpture was that it should provide handsome decoration. Geometric or floral motifs could serve that purpose both simply and elegantly, but Greek sculptors often daringly sought more exciting solutions.

SPACES AND SHAPES TO DECORATE

Three areas on Greek temples invited sculpted decoration: the triangular pediments at the two ends of the gabled roof, the almost square metopes (a characteristic of the Doric order of architecture) and the long, narrow running friezes (which were normally associated with the Ionic order). These three areas are shaded in the drawing (opposite and above). Ambitious sculptors chose to fill these spaces with images of their treasured myths, a choice that presented some interesting challenges.

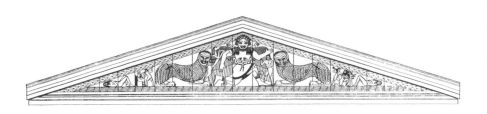

PEDIMENTS AND THEIR PROBLEMS

A pediment is a long, low triangle. It is not easy to arrange figures within it so that they will fill the space harmoniously, tell a story, and tell it coherently. This is obvious from the difficulties encountered by the artist who carved huge figures in relief to decorate the pediment of the Temple of Artemis in Corfu in the early years of the sixth century BCE (around 580 BCE; above and opposite). The high centre of the triangle is filled by a huge Gorgon, whose terrifying features would have been considered effective in warding off evil spirits. Her role, however, was more than that of a guardian; she was also involved in a story. This Gorgon was Medusa, whose fate it was to be decapitated by the hero Perseus. At the moment of her death, she gave birth to two children – Pegasus, the winged horse, and Chrysaor, a hero – both of whom sprang from her neck as her head was severed from it. Her bent knee pose is meant to indicate that Medusa is running away from Perseus (who is not shown) while the unhappy outcome of her attempted escape is suggested by the presence of her two children: Pegasus on the left and Chrysaor on the right.

> **Decoratively the pediment is superb;
> narratively it is incoherent**

Medusa and her children are flanked by crouching panthers. They do not have her double function of simultaneously protecting the temple and suggesting a myth; they are just guardians of the temple whose reclining posture enables them to fit comfortably into the awkward shape of the pediment.

Tucked into the corners are several tiny figures. These are purely narrative. Those on the left come from the story of the Fall of Troy: King Priam, seated, is about to be killed by the Greek attacking him. A dead Trojan lies behind him. The figures on the right are participants in the battle of the gods and giants. The great god Zeus,

Reconstruction drawing of the west pediment of the Temple of Artemis, Corfu
c.580 BCE

Medusa was the only mortal one of the three Gorgon sisters, all of whom had visages so terrible that merely to look at them could turn a viewer to stone. The image of the head of a Gorgon was sometimes used in isolation in a variety of contexts as a device to scare off evil spirits.

Opposite: Central figures from the west pediment of the Temple of Artemis, Corfu
c.580 BCE
Limestone, height 318 cm (125¼ in.)
Archaeological Museum, Corfu

Medusa is shown simultaneously fleeing and giving birth to her children, Chrysaor (to the right) and Pegasus (to the left) with little more preserved than his foreleg resting on the shoulder of his mother.

wielding his thunderbolt, has brought a giant to his knees. Another lies supine in the corner.

Decoratively the pediment is superb; narratively it is incoherent. Three completely unrelated stories are told and they are told on totally unrelated scales. This may not have bothered worshippers looking at the pediment at the time it was made. They might be pleased simply to recognize the three stories and to enjoy each one in itself. They probably would not have thought of the pediment as a single space in which a unified image of reality should appear.

But demand for convincing and coherent representation – even within the awkward triangular frame – soon arose.

We have seen that when the Greeks looked at the statue of a man, they (unlike earlier peoples) thought it should look like a real

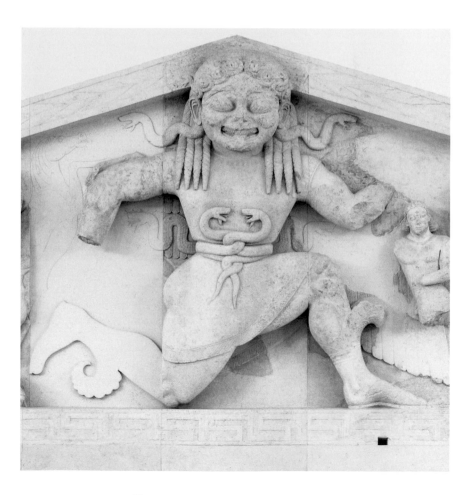

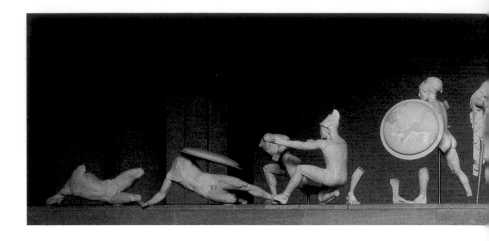

man, and it was to meet this demand that increasingly naturalistic images were produced. The Greeks thought similarly about pediments. At first they were satisfied with a pleasant design and an assemblage of stories enacted by large and small actors depending on the space available. But in time they came to think of the pediment shelf as a sort of stage on which a plausible vision of a real situation should appear. Artists, therefore, strove to fill the space with a single story, intelligibly told by figures all conceived on a single scale. This was a challenging conundrum, but within a century, a satisfactory solution had been found.

It lay in the decision to portray a complex scene of action.

Above: Greeks and Trojans in battle with Athena presiding on the west pediment of the Temple of Aphaia, Aegina
c.500 BCE
Marble, height
165 cm (70 in.)
State Collections of Antiquities, Munich

The conundrum of how to fill a sloping pediment with figures all on the same scale and enacting a single story was solved by the choice of a battle scene presided over by a deity as the theme.

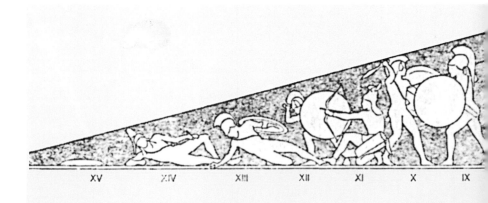

XV · XIV · XIII · XII · XI · X · IX

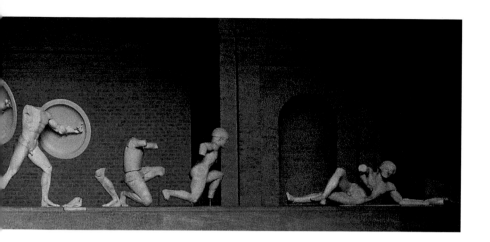

Below: Reconstruction drawing of the west pediment of the Temple of Aphaia, Aegina c.500 BCE

This was one of the earliest pediments to make use of this successful composition.

They came to think of the pediment as a sort of stage

The designer of the west pediment at Aegina, carved around 500 BCE, chose to depict a mythological battle (above and below). The mighty goddess Athena stands in the centre, her head reaching to the apex of the pediment. On either side mortal heroes, who are smaller than she, fight and fall; the incidents of war being so arranged that those nearest the middle stand while those further away stagger, lunge, crouch or lie in conformity with the slope of the pediment. The same scale was used for all the figures (now carved fully in the round); the violent theme gave plausibility to their different heights.

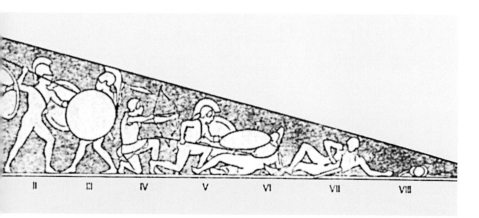

II III IV V VI VII VIII

The next generation saw a tour de force in pedimental design: the east pediment of the Temple of Zeus at Olympia (465–457 BCE; above and below). Here there is no violent action, and yet within a quiet scene, a story is compellingly told with figures of uniform scale, the whole pediment being harmoniously filled.

The scene is tense, unified and effective

In the centre stands Zeus, again a divinity who is taller than mere mortals. On his right (our left) stands Oinomaos, king of Elis. He is offering his daughter as bride to any man who can carry her off in his chariot and reach the Isthmus of Corinth before Oinomaos overtakes and kills him. Oinomaos has divine horses, and twelve suitors have already perished. A young man, modest in demeanour, stands to the right

Above: Preparations for the race between Pelops and Oinomaos on the east pediment of the Temple of Zeus, Olympia (central figures)
465–457 BCE
Marble, entire east pediment 347 x 2639 cm (136⅝ x 1039 in.)
Archaeological Museum of Olympia, Olympia

Below: Reconstruction drawing of the east pediment of the Temple of Zeus, Olympia

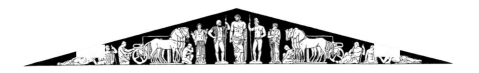

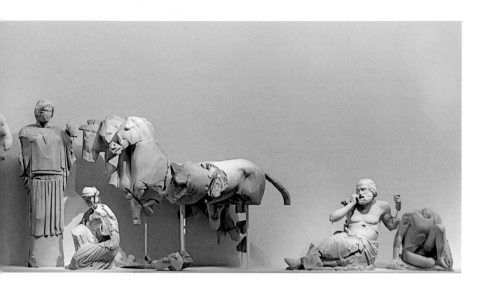

Since the statues were no longer in situ on the pediment when they were found, the exact positions of the five central figures (except for the god) were not certain. Although it was obvious that male figures had to flank the central god and female figures flank the men, the uncertainty about their original placement allowed for different scholars to make reconstructions in which they placed either Pelops or Oinomaos to the left or the right of the central god and to pair the women with the men in different combinations.

listening. He is Pelops, destined to defeat the old king and marry the girl. The prospective bride and her mother flank the men. Next come chariot teams; the horses' heads, since they are higher than their rumps, are turned symmetrically towards the centre. Behind them, on one side squats a charioteer holding the reins of the chariot, and on the other side, a seer, dismayed, is shown seated, peering into the future, where he witnesses the terrible disaster in store for Oinomaos. Servants and other subordinate characters sit near the corners, which are neatly filled with reclining river gods, their legs extending into the furthest angles.

-

The horses' heads, since they are higher than their rumps, are turned symmetrically towards the centre

-

The subtle differences in the characterizations of the arrogant Oinomaos and the modest Pelops, the intense involvement of the principal characters and the detachment of the servants – one boy is passing the time absentmindedly playing with his toes – are all part of the early fifth century BCE exploration of personality and mood which we saw in the Kritios Boy (pages 20, 22 and 28) and the Zeus of Artemisium (pages 29, 30 and 31).

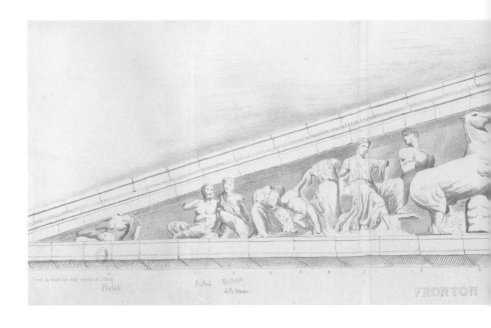

BRILLIANTLY BREAKING THE RULES

The pediments of the Parthenon (above), carved a generation later (438–432 BCE), are even more ambitious. The temple was unusually broad, so the pediments had to be extraordinarily wide, a change in proportions that intensified the problems inherent in pedimental design. While the pediments at Olympia were comfortably filled with about fifteen figures, well over twenty were required to fill each pediment of the Parthenon. Since these were placed higher up from the ground than usual, they were deeply carved so that they would catch the light and remain intelligible at a distance. Though they were boldly designed, these figures are finished with great refinement, and even the backs, which would not have been visible once they were in place, have been completed with scrupulous care.

-

**Beyond the striking central composition,
things seem to fall to pieces**

-

The west pediment showed the contest of the goddess Athena and the god Poseidon for the patronage of Athens (above). The two huge deities occupied the centre, pulling away from each other. Teams of horses reared up on either side. (We have to rely on a

**The west pediment of
the Parthenon, Athens**
1674
Drawing in black
and red chalk by
Jacques Carrey, left half
27 x 45 cm (10⅝ x
17⅞ in.); right half 20 x
39.5 cm (7⅞ x 15½ in.)
Bibliothèque Nationale
de France, Paris

**The pediment, made
of marble and carved
from 438–432 BCE,
represented Athena and
Poseidon vying for the
patronage of Athens.
This drawing, fortunately
made around 1674 before
the pediment suffered
greater damage, captures
the dramatic excitement
of the divine competition
at the centre and the
way the intensity
diminishes as it eddies
out to the sides.**

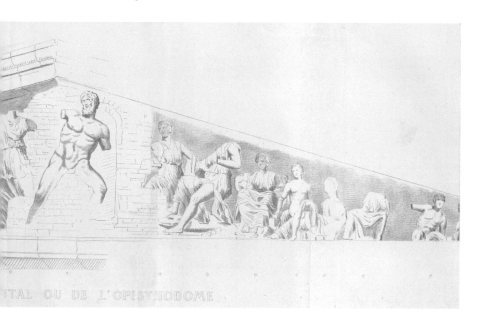

seventeenth-century drawing for our information about the design,
as most of the sculptures have since been removed or destroyed.)
From the violent thrusts and counterthrusts in the middle of the
pediment, waves of excitement eddy out, finally coming to rest
in the calm and unconcerned reclining figures of river gods at
the corners.

The river god in the left corner, now visible at close quarters in
the British Museum, London, reveals the combination of grandeur
and subtlety that distinguishes the sculpture of the Parthenon
(see also pages 59 and 60–63). Anatomy is portrayed naturalistically
but without finicky detail; powerful muscles flex and ripple to
contrast with the inanimate yet graceful fall of soft drapery.

The sense of drama and excitement in this pediment is
marvellously conveyed (above), but beyond the striking central
composition, things seem to fall to pieces almost as they did in the
Corfu pediment (page 48). The gods and goddesses at the sides
witnessing the spectacular event taking place in their midst are
very shrunken in scale. Notice how tiny the river god in the corner
is compared with the Poseidon in the centre. As far as the design
is concerned, the artist has overreached himself and has tried to
accommodate too many figures. The dazzling brilliance of the
carving of the few surviving figures has, however, tended to divert
attention from the imperfections of the composition.

METOPES: FEW BUT TELLING FIGURES

Metopes, being nearly square, are easier to decorate and fill than pediments. If, however, the artist wants the story presented in a metope to be intelligible at a distance, he must carefully choose the moment to be illustrated and use no more than three or four figures.

The sculptor of a metope on the Sicyonian Treasury at Delphi, carved around 560 BCE, has produced a fine piece of decoration (below). (A treasury was a small building erected in a sanctuary to hold the dedications and offerings made by the people who built it.) The metope now shows three heroes – originally there was one more – marching off to the right proudly accompanying the oxen they have stolen in a heroic cattle raid. They occupy the full height of the metope, a triad of parallel vertical figures. They hold their sloping spears at the same angle and walk in step with the cattle, whose legs, meticulously aligned, recede into the background of the relief. A fine pattern emerges, elegantly composed of the repeated shapes so appreciated in the sixth century BCE (page 17).

The metopes on the Temple of Zeus at Olympia (465–457 BCE), six over the front porch and six over the back, illustrated the twelve labours of Heracles, one labour to each metope.

One labour required Heracles to fetch the apples of immortality from the garden of the Hesperides. Heracles persuaded Atlas, whose geographical knowledge surpassed his own, to fetch the apples and bring them to him while he held up the heavens in Atlas's place. The metope (opposite) shows Atlas, rejoicing in his unusual

Heroic cattle raid
Metope from the
Sicyonian Treasury,
Delphi, c.560–550 BCE
Limestone, height
62 cm (24⅜ in.)
Archaeological Museum,
Delphi

**The carefully repeated
rhythm of upright
striding men carrying
their sloping spears on
their shoulders creates
a satisfying decorative
pattern on the metope.**

Atlas bringing Heracles the apples of the Hesperides in the presence of Athena
Metope from the Temple of Zeus, Olympia, c.460 BCE
Marble, height 114 cm (44⅞ in.)
Archaeological Museum, Olympia

The three vertical figures in this metope are subtly varied in their positions, one shown fully frontal, the next in full profile and the third in three-quarter view.

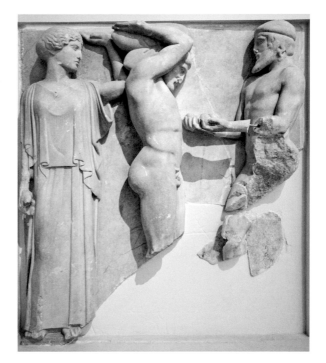

freedom of movement, striding to the left, holding the apples in his outstretched hands. Heracles faces him, oppressed by the burden, which, despite a folded cushion, rests heavily on his shoulders. The goddess Athena, his patroness, stands at the far left, one hand raised in an easy gesture of aid to the hero.

Something subtler than the parallel lines and repeated patterns on the metope from the Sicyonian Treasury (opposite) relates the three figures on the Olympia metope (above). Atlas, the only figure in action, moves in from the right. His chest is shown in three-quarter front view; his extended forearms make a strong horizontal contrast with the predominant verticals of the design and draw our attention to the apples in his hands. Profile to profile he faces Heracles, who is shown in side view. Athena, fully frontal, majestic and still, brings the movement to an end. Athena's sympathy with Heracles is delicately indicated not only by her upraised hand but also by the turn of her head – in profile, like Heracles, confronting Atlas.

The master of the Olympia metopes could also portray conflict superbly. He showed Heracles fighting the monstrous Cretan Bull (overleaf) as a composition based on two crossing diagonals, so

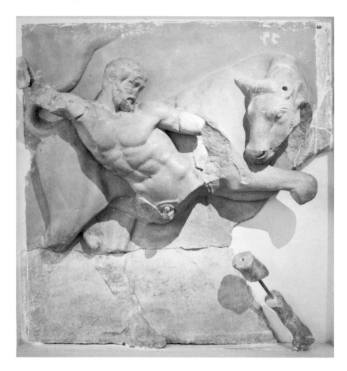

**Heracles struggling
with the Cretan Bull**
Metope from the
Temple of Zeus at
Olympia, c.460 BCE
Marble, height
114 cm (44⅞ in.)
Louvre, Paris

**The vigour of the
confrontation of man
and monster is captured
by the explosive diagonals
that dominate the
composition.**

that both figures could appear especially large in relation to those
on other metopes. In a splendid invention designed to convey the
intensity of the struggle, he makes the hero wrench the head of
the gigantic bull round to confront him face to face.

The dynamism of this explosive composition was much
appreciated in later times. The same structure underlies the conflict
of the central figures in the west pediment of the Parthenon (pages
54–5) and it is also used for one of the most striking metopes on
the Parthenon (opposite).

-

**The tense struggle is visually accentuated by the
play of light and shadow**

-

The Parthenon was exceptionally richly decorated with
architectural sculpture. Not only were the unusually wide pediments
crammed with figures, but all ninety-two of the metopes on the
four sides of the temple were also carved (447–438 BCE). Some of
those on the south, almost the only ones reasonably well preserved,

Lapith fighting a centaur
Metope from the
Parthenon in Athens,
c.447–438 BCE
Marble, height
120 cm (47¼ in.)
British Museum, London

**By showing the
combatants pulling
apart from one another
rather than closing in on
each other, the sculptor
brilliantly fills the whole
space of the metope
leaving no gaps at
the sides.**

represented the conflict of the Lapiths (mythical people living in the north of Greece) with the centaurs (monsters that were part man and part horse). In one metope (below), man and monster pull energetically away from each other; the tense struggle is visually accentuated by the play of light and shadow on the deep folds of the cloak that falls behind and over the arms of the Lapith. The Lapith's body is rendered by such a subtle wealth of anatomical detail and by transitions of such delicacy and softness as to make the Olympia metopes, with their grand simplifications, look by contrast ruggedly severe.

From the schematic, handsomely patterned design of the sixth-century BCE metope on the Sicyonian Treasury (page 56), the Greeks gradually evolved the dynamic, classical balance of the finest metopes of the Parthenon (below).

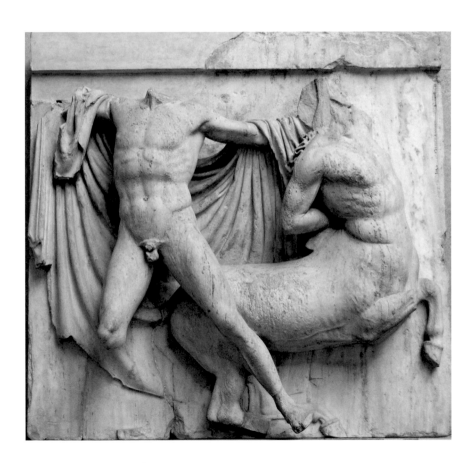

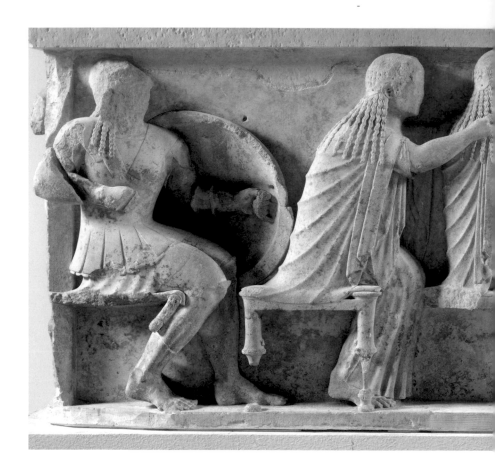

FRIEZES: DIFFICULTIES IN DESIGN

Friezes presented different problems of design from metopes.
A frieze was an immensely long, narrow ribbon for which it was not easy to find a satisfactory theme. One possible subject was a battle, with combatants strung out in groups over a wide area. Another possible subject was an assembly.

-

A frieze was an immensely long narrow ribbon

-

An assembly of gods was chosen for part of the frieze on the Siphnian Treasury at Delphi (above), constructed shortly before 525 BCE. Five gods sit facing right, one behind the other. Although the gods are identifiable as individuals and differ slightly in the way

**Five seated gods
in conference**
Part of a frieze from
the Siphnian Treasury,
Delphi, c.525 BCE
Marble, height 60 cm
(23⅝ in.)
Archaeological Museum,
Delphi

**The repeated pattern
made by the vertical
upper bodies of the
seated figures and the
horizontals of the stools
on which they sit brings
unity to this multifigure
frieze.**

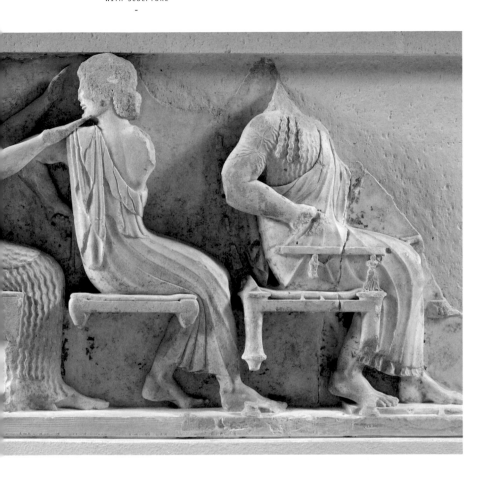

they sit and the position of their arms and legs, the overall effect of
the upright seated figures on their virtually identical, clearly carved
stools is one of handsome ornamental pattern. Within each figure
certain motifs – strands of hair or folds of drapery – are repeated
for decorative effect and the scene as a whole is composed as a
typically sixth-century BCE design of rhythmically repeated verticals
and horizontals.

The subject chosen for the frieze that, unusually, decorated
four walls within the colonnade of the Parthenon (442–438 BCE)
was a procession honouring the goddess Athena (overleaf, top).
It was designed so that the participants in the sculpted frieze appear
to accompany the observer walking beside the temple in the same
direction. On each of three sides, the procession moves in one
direction; at the front, the two branches of the procession converge
toward the centre, producing a natural point of rest for the eye.

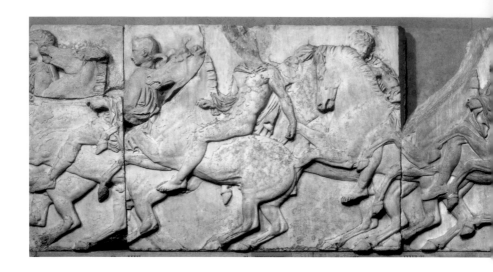

The flow of the figures is unified but not monotonous. Sometimes the procession is dense and the figures move along quickly, as in the cavalcade (above), whereas at other times the pace is more measured (below) or even stately (page 120).

The exquisite carving of the frieze is exemplified by a detail of some youths bringing a heifer to sacrifice (below). The austere simplicity of the Olympia metope (page 58) looks

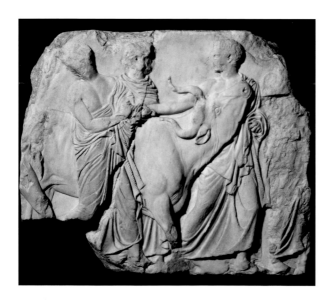

Heifer led to sacrifice
Part of the Parthenon frieze, 438–432 BCE
Marble, height
100 cm (39⅜ in.)
British Museum, London

The body of this young heifer is carved with such subtlety and sensitivity that it is hardly surprising that it inspired the poet John Keats's line on 'that heifer lowing at the skies'.

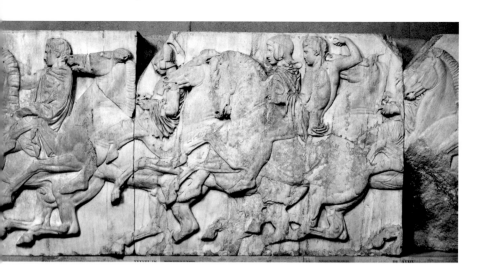

Cavalcade
Part of the Parthenon
frieze, 438–432 BCE
Marble, height
100 cm (39⅜ in.)
British Museum, London

**The repetitive character
of horsemen riding in an
orderly troop is enlivened
by small variations in the
positions of the heads
of the riders and their
steeds and other subtle
differences in pose or
costume.**

almost harsh in comparison with the richly expressive carving on
the Parthenon frieze. Notice how differently the heifer is rendered
from the Cretan Bull. The Cretan Bull is portrayed in terms of
grand simplifications, while the heifer from the Parthenon shows
distinctions between hard bone, elastic muscle and soft layers of fat,
all indicated by means of subtle anatomical detail and transitions of
great delicacy.

KEY QUESTIONS

Can architectural sculpture carry religious messages?
Are there other places aside from pediments, metopes and
 friezes where sculpture can be used to decorate architecture?
When and where should modern architecture make use of
 sculpture?

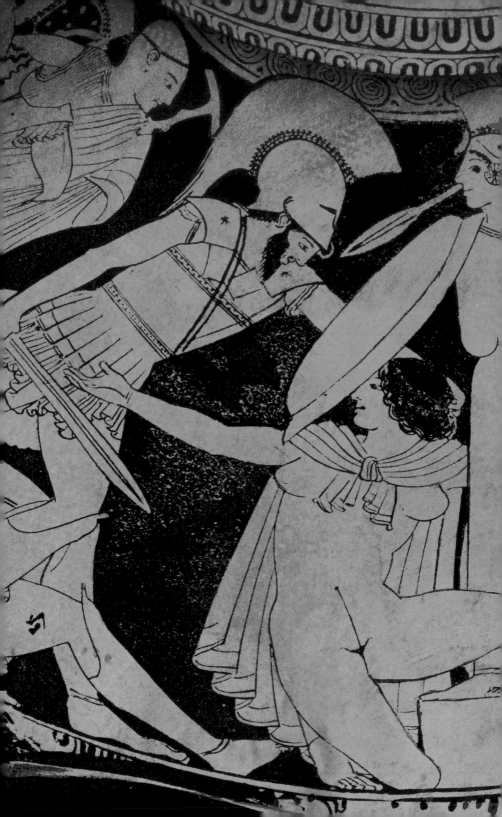

GREEK PAINTING: CREATING A CONVINCING IMAGE

-

Illusionistic paintings showing fully rounded
forms in a plausible space are taken for granted nowadays.
Before the Greeks, they did not exist;
the Greeks invented them

-

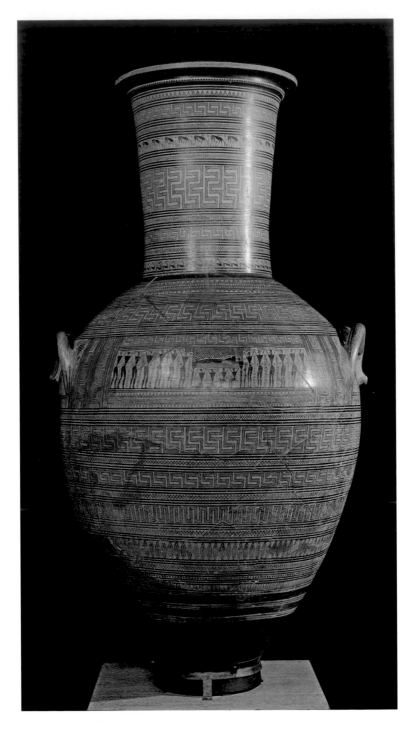

Large pottery vase serving as a funerary monument (Dipylon Amphora)
755–750 BCE
Ceramic, height 160 cm (63 in.)
National Archaeological Museum, Athens

Such huge and magnificent vases were used as grave monuments for only a short time, eventually being replaced by grave monuments made in stone – either reliefs or freestanding statues.

The Greeks made wonderful paintings, considered by many even better than the sculptures of the time. Not a scrap of them survives. We know about them because some writers praised them and sometimes even described them in detail.

These famous works were painted on wood – large murals, as well as small panels – and wood disintegrates in the Greek climate. Pottery, by contrast, does not disintegrate. Luckily, Greek painted pottery, surviving in masses, can not only throw light on the lost masterpieces on wood but also help us to see how Greek painting developed.

PAINTING ON POTTERY

As early as the eighth century BCE, around the time when the *Iliad* and the *Odyssey* were composed, grand and impressive works were being created. The pot shown opposite is huge, about a metre and a half in height, but the elements that decorate it are small. They cover the entire surface with a network of light and dark elements, subtly varied to emphasize the structure of the vessel: offset lip, cylindrical neck, expanding shoulder and wide belly tapering to the foot. Strong triads of horizontal lines divide the surface into bands. All the patterns within the bands, except for those decorated with living creatures – the grazing deer and reclining goats on the neck and the figures on the belly – are designed to be either vertical or horizontal. In this way the decoration is made to enhance the stable and monumental appearance of the vessel and to contrast piquantly with its curving contour.

-

The pot shown opposite is huge, but the elements that decorate it are small

-

Human figures appear in only one small but important section: the panel between the two handles. They are slim, elegant stick figures painted in flat silhouette. The scene represents mourners around a bier. The whole gigantic piece of pottery was used as a grave marker, and the sombre, controlled, meticulous decoration accords well with this function.

TELLING A STORY ON A VASE

By the seventh century BCE, human figures and their activities
had become the most important part of vase painting for certain
artists in several areas of Greece. Homer's poems were by then very
popular and some vase painters longed to follow the poet's example
and themselves become tellers of tales. An artist might, therefore,
simplify the traditional patterned decoration and banish most of it
to the bottom of the vase in order to clear the principal area for the
presentation of an exciting story (below).

From this time on, many vase painters, like the artists who later
carved architectural sculptures, strove to show men (and monsters)
in action. Greek mythology was rich in tales of adventure – Homer
recounted some of them in the *Iliad* and the *Odyssey* – and they
provided an unending source of inspiration for artists.

The story represented below is taken from Book IX of the
Odyssey, which described how Odysseus and his men were trapped
in the cave of the huge and terrible one-eyed, man-eating Cyclops.
The Cyclops closed the mouth of the cave with an enormous
boulder, too large for the men to move. Even if they had succeeded
in killing the Cyclops, they would have perished, trapped in the cave.
Ingenious Odysseus realized this and so devised a way to blind the

**Odysseus and his
companions blinding
the Cyclops (krater)**
Signed by Aristonothos
as potter, c.650 BCE
Ceramic, height
35.8 cm (14⅛ in.)
Capitoline Museums,
Rome

**Slight deviations from
pure repetition transform
this image from a pattern
into a story; the men are
all cooperating in pushing
the stake into the eye
of the seated giant who
holds a cup to indicate
that he is drunk; the last
man, at the far left, gives
the attack added force
by pushing against
the border enclosing
the scene.**

monster, get the Cyclops to move the boulder himself and then slip out of the cave with his men undetected.

The painted scene shows Odysseus and his men, after having made the Cyclops drunk, driving a great stake into his single eye. The men are drawn in flat silhouette, except for their faces that are drawn in outline. The Cyclops, who looks a bit small for a giant, sits on the ground to the right.

The artist had to try to satisfy two rather contradictory conditions: to decorate his vase with an effective pattern and to make his story clearly intelligible. He has succeeded in telling the tale with great liveliness and has, at the same time, made a pleasing pattern of the repeated forms of the men working in unison. We happen to know who made this vase (opposite), for Aristonothos was one of the first potters to put his name on his work. From now on potters and painters somewhat irregularly signed their work. Many of the best artists, however, never signed, and even good artists with known signatures often left their finest pieces unsigned.

STORYTELLING IN THE BLACK-FIGURE TECHNIQUE

Storytelling eventually came to be the overwhelming concern of many painters who decorated vases, especially those who lived in Athens. It captivated and enthralled them; other considerations became subordinate. It provided a powerful impetus towards naturalism, for painters were constantly looking for ways to make their stories more convincing – to make them come alive for their audiences.

Vase painters longed to follow the poet's example and themselves become tellers of tales

It was difficult for painters to achieve this goal while working just with silhouettes. Most stories required figures to interact and overlap, but the overlapping of silhouettes only leads to confusion. Some painters experimented briefly with outlining their figures but the outlines looked disappointingly thin on the burnished, curving surface of a pot. The conflicting demands of persuasive narration and effective decoration stimulated the search for a better solution.

This came with the invention of the black-figure technique. The artist painted his figures in silhouette as before, so that they would look bold and telling. The paint he used was a specially

prepared clay slip that turned black when fired. While this was
still moist, he incised contours and inner markings with a sharp
instrument that removed the paint along the line of incision and left
the outlines clear. He also added touches of white and purplish-red,
so that the scenes became more colourful. These added colours
proved less durable than the black paint and the basic orange of
the background, so that on many black-figure vases little trace
of them remains.

-
An extremely moving image has been created
-

The vase painter Kleitias obtained wonderful effects with the
black-figure technique around 570–560 BCE (above). The picture
of Ajax carrying the body of Achilles is part of the decoration on the
handle of the richly painted so-called 'François Vase'. An extremely
moving image has been created. The great hero Ajax rises with
difficulty under the burden of the even greater hero whom he lifts.

**Ajax carrying the
body of Achilles (handle
of the François Vase)**
Signed by Kleitias as
painter and Ergotimos
as potter, c.570 BCE
Attic black-figure
pottery, height (of whole
vase) 66 cm (26 in.)
Archaeological Museum,
Florence

**An extraordinary richness
of emotion is packed
into this simple drawing
of one warrior rescuing
the body of his fallen
comrade.**

Ajax carrying the body of Achilles (see opposite) with the incision removed

The body of Achilles is draped limply over the shoulders of his friend. The arms drop lifelessly, the hair hangs heavily. Notice the closed eye of the dead Achilles and how it contrasts with the wide-open, sorrowful eye of Ajax. Achilles was a fast runner (Homer calls him 'swift-footed Achilles'), but death has extinguished his speed. Kleitias recalls what Achilles was in life; look how carefully he has drawn the kneecaps and how he has indicated the strong muscles in the legs. The picture above reveals how unintelligible this image would be if attempted in silhouette alone. The incised lines that articulate the figures are essential.

A generation later, in the third quarter of the sixth century BCE, there lived the greatest of all black-figure masters: Exekias. A good example of the exquisite refinement of his style is the image showing the same two heroes that had been painted by Kleitias, Ajax and Achilles, but here in a happier moment (overleaf). The heroes' finely embroidered cloaks are depicted with the most delicate incision. The serene composition captures the tranquillity of the scene and the absorption of the heroes. As they bend towards the gaming board, the curve of their backs echoes the

curve of the vase. Exekias shows that he was acutely aware of the vessel he was decorating. Not only does he make the outlines of the heroes follow the outlines of the pot, he also places their spears so that they lead the eye to the top of the handles and arranges the shields behind the heroes so that they continue the vertical line formed by the lower part of the handles.

The stature of Exekias becomes clear if one compares his vase (below) with one painted by a lesser artist (opposite) who has taken over the theme, and, to a large extent also the composition, from Exekias. The differences are marked. Only the shield of the left-

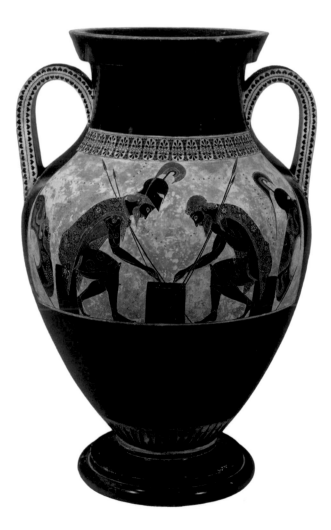

Ajax and Achilles playing a board game (amphora)
Signed by Exekias as painter and potter, c.540–530 BCE
Attic black-figure pottery, height 61 cm (24 in.)
Vatican Museums, Rome

The delicacy of the execution and the boldness of the design make this one of the most outstanding surviving works of Greek art.

hand hero relates to the shape of the vessel and the embroidery on the cloaks is simpler; as neither hero wears a helmet, the composition lacks unity and tends to fall apart into two virtually symmetrical halves. Still, this is a good artist; it is only that his painting lacks the genius that makes Exekias's work so outstanding.

THE EMERGENCE OF NEW POSSIBILITIES

Few vase painters could attain Exekias's standard, though most who were active in the next generation continued to use the black-figure

Ajax and Achilles playing a board game (amphora)
The name of the painter is not known, c.525–520 BCE
Attic black-figure pottery, height 55.5 cm (21⅞ in.)
Museum of Fine Arts, Boston

The basic design by Exekias was copied many dozens of times but usually either with both heroes bareheaded (as here) or both helmeted; only once again in surviving vase painting does a single helmeted hero unify the two halves of the image.

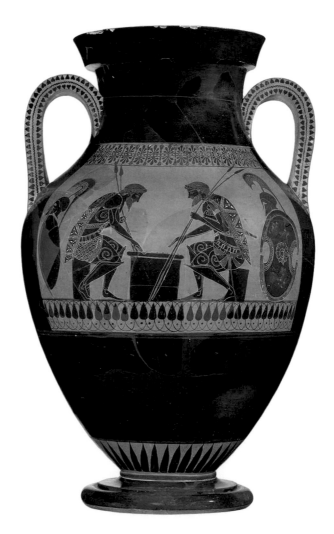

technique. One of the more imaginative, however, decided to experiment and try something different (below). He simply reversed the traditional colour scheme: instead of painting black figures on an orange-red ground, he left the figures in the natural colour of the clay and painted the background black. This new red-figure technique had many advantages. It preserved the strong decorative contrast of the colours but it gave greater freedom to drawing, because a supple brush could be used for the details instead of a rigid engraving tool. Anatomy became livelier, cloth softer and the figures more vibrant with life.

The red-figure technique was invented around 530 BCE and was quickly adopted by the best and most ambitious painters. Mediocre painters continued working in black-figure until the middle of the fifth century BCE and though the older technique was used for special purposes right up until the second century, it had lost its fascination.

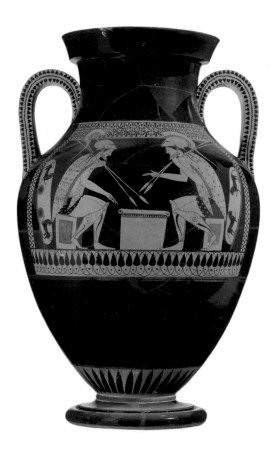

Ajax and Achilles playing a board game (amphora)
(opposite side of the amphora on page 73)
The name of the painter is not known, c.525–520 BCE
Attic red-figure pottery, height 55.5 cm (21⅞ in.)
Museum of Fine Arts, Boston

Making both heroes helmeted to create a more symmetrical design has destroyed the subtle unity of the image originally created by Exekias.

Euthymides, working in the last decade of the sixth century BCE, was delighted with the facility that red figure gave him. Like artists carving reliefs at that time and also those doing free painting (as we learn from ancient writers), Euthymides was very concerned with problems of three-dimensional representation, that is, with showing full, round figures convincingly rendered by means of foreshortening (below). To explore these effects, he did not need a story to illustrate; scenes from everyday life were just as good. These had formed a minor current in black-figure painting. On the vase shown below, he depicts three drunken revellers carousing. The central one is most striking. He is drawn from the back, a novel point of view. Euthymides was so pleased with this work that he wrote on the vase 'Euphronios (a rival vase painter) never did anything as good': a proud boast, for surviving works by Euphronios are powerful indeed. The vaunt gives us a vivid insight

Revellers (amphora)
Signed by
Euthymides as painter,
c.510–500 BCE
Attic red-figure pottery,
height 60.5 cm (23⅞ in.)
State Collections of
Antiquities, Munich

**The unedifying scene
of three drunken men
carousing gives the
gifted vase painter an
opportunity to show off
his skill in depicting fully
rounded figures cleverly
foreshortened.**

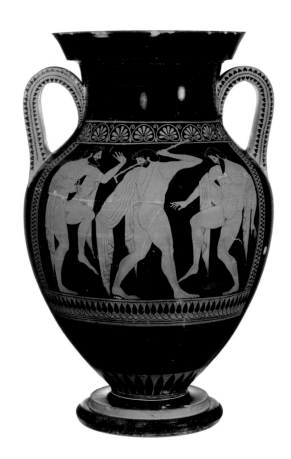

into the lively competition between artists that spurred them on to face and overcome ever new problems.

No one at the time could have challenged the inventiveness and excellence of Euthymides's drawing, nor could anyone have failed to marvel at the way he suggested the massiveness and volume of his figures. The surface of the vase has been transformed into a field for the exhibition of advances in foreshortening. For the best artists there could now be no turning back. And yet was it appropriate to decorate the curving surface of a vase in this way? Are not plain silhouettes, or even the highly elaborated silhouettes of Exekias (page 72), more suitable? Regarded purely as applied decoration, is not the very early vase (page 66) the most satisfying? Perhaps, as we have seen before, progress in one direction (naturalistic drawing) has produced problems in another (decorative effectiveness).

By the beginning of the fifth century BCE, the red-figure technique had been thoroughly mastered. Now it could be used expressively, as is shown in a painting on a vase that depicts the mythological Sack of Troy (above). The old king, Priam, sits on an altar. This ought to have assured him of divine protection, but an arrogant young warrior grasps the old man by the shoulder to steady him as he prepares, heartlessly, to deliver the death blow.

The Sack of Troy: Priam is killed on the altar (hydria shoulder)
The name of the painter is not known, c.500–490 BCE
Attic red-figure pottery, height (of the entire hydria) 42 cm (16½ in.)
National Archaeological Museum, Naples

This brutal killing of Priam, the aged king of Troy, was, to the Greeks, emblematic of the horrors of war.

The Sack of Troy: Cassandra wrenched from the statue of Athena (hydria shoulder)
The name of the painter is not known, c.500–490 BCE
Attic red-figure pottery, height (of the entire hydria) 42 cm (16½ in.) National Archaeological Museum, Naples

Cassandra, the daughter of Priam, was a prophetess who foresaw the doom of Troy. She was taken as a captive to Greece and murdered there by the wife of the Greek general who had acquired her as his prize after the sack of Troy.

King Priam puts his hands to his head. It is a gesture less of self-protection than of despair. His grandson, brutally murdered, lies on his lap, the child's body gashed with horrible wounds. How different is this scene from the crude and simple image of the same subject on the Corfu pediment (page 48, left corner)!

Another part of the painting (above) shows a Greek warrior harshly pulling a woman away from the statue of a goddess to which she clings for protection. Notice the eloquence of the pleading hand she extends towards him. Old men, children, defenceless women – these are the ones who suffer in war. The artist knew it well; he was an Athenian living at the time of the Persian Wars.

POLYGNOTOS AND WALL PAINTING

The most famous artist in the quarter-century following the Persian Wars (around 475–450 BCE) was Polygnotos. He was a mural painter, and none of his works survive. But from what ancient writers tell us and from imitations and adaptations of his and his contemporaries' work in sculpture and vase painting, we can get some idea of what his revolutionary paintings must have been like.

The characters of the four and their attitudes towards the spell-binding music are all finely differentiated

Polygnotos's main interest was the delineation of human character, revealed in quiet and intense scenes. The still, tense, expressive group of figures in the east pediment of the Temple of Zeus at Olympia (pages 52–3) with its sensitively rendered contrasting personalities, shows a profound influence from Polygnotos. Something of his special quality can also be seen echoed in a vase painting depicting Orpheus, the legendary musician who could charm animals and trees and even the gods of the underworld with his songs, playing to four Thracian listeners (above). The characters of the four and their attitudes towards the spellbinding music are all finely differentiated. The youth to the left of the singer has yielded entirely: he closes his eyes and listens enraptured. His companion (far left) leans on his shoulder and gazes dreamily at the singer. The two men at the right seem less well disposed towards the music. The one closest to Orpheus stares intently at him, angrily trying to fathom the power of his art. The one at the far right is thoroughly disapproving and turns to leave (notice his feet), but he looks back; he cannot break the spell. Orpheus himself, absorbed in his singing, belongs in a wholly different realm.

Orpheus playing to four Thracian listeners (krater)
The name of the painter is not known, c.450 BCE Attic red-figure pottery, height 50.7 cm (20 in.) Antikensammlung, State Museums of Berlin, Berlin

The subtle differences in mood and character of the five figures depicted here probably reflect the achievements of the most notable wall-painter of the time, Polygnotos.

Such a static scene works well in a small panel on a vase, but Polygnotos decorated great walls with huge compositions filled with a large number of figures. Depictions of action make for exciting arrangements, but since Polygnotos wanted to reveal character through quiet, motionless figures, he had to devise a different way of making his compositions lively. To this end, he distributed his figures up and down the wall at different levels so as to cover the space with interesting groups. A possibly unexpected consequence of this innovation was that the figures higher up looked as if they were further away; that is, the figures appeared to be receding behind each other, and the wall itself ceased to appear entirely flat but began to suggest an indefinite space.

We do not know whether Polygnotos was pleased with the illusion of depth created by his novel distribution of figures or was disappointed that the pattern he had carefully composed on the surface of his painting had been disrupted by the suggestion of space. In any case, what his paintings threatened to do was to pierce a hole in the wall they decorated, which must have created a startling, even alarming, effect when it first appeared.

A few vase painters tried to copy Polygnotan compositions (below). It was a mistake. The shiny black background negates the suggestion of space that is possible on a pale wall, and the scatter of figures looks odd and purposeless. Now, for the first time, vase painting and free painting went their separate ways.

Mythological figures in a landscape (detail from a krater)
The name of the painter is not known, c.460–450 BCE
Attic red-figure pottery, height (of the entire krater) 54 cm (21¼ in.)
Louvre, Paris

The suggestive placement of figures scattered through a landscape as depicted in (lost) wall paintings was virtually impossible to translate effectively into red-figure vase painting with its conventional black background.

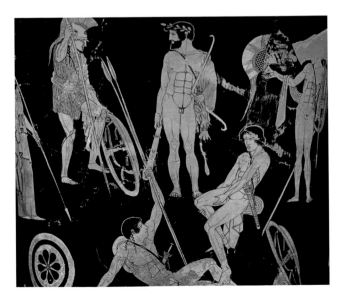

THE ILLUSION OF SPACE

We take it for granted that three-dimensional objects and three-dimensional space can be represented on a flat surface; illusionistic pictures are part of our everyday experience. Before the Greeks, they did not exist. The Greeks invented them.

Euthymides (page 75) and his contemporaries in the late sixth century BCE began using foreshortening in their drawing of individual figures in order to give them the appearance of being three-dimensional. By the end of the fifth century BCE, the painter Parrhasios was supposed to have drawn outlines so suggestive that they seemed to reveal even what was concealed. This he seems to have done without the aid of internal markings or shading. Something of his achievement may be reflected in a white-ground vessel used as a funeral offering (right and opposite); it shows striking economy of line and sparseness of internal marking combined with an impressive suggestion of volume.

-

Parrhasios was supposed to have drawn outlines so suggestive that they revealed even what was concealed

-

Zeuxis, a contemporary of Parrhasios, also wanted his figures to appear to have mass. He chose to indicate mass through the clever use of shading rather than through suggestive outline. His was the approach that captured the imagination of later painters. Parrhasios's immense skill in drawing was much valued, and examples of his work were treasured for centuries, but it was Zeuxis's more painterly method of indicating volume by means of modelling that was developed further. Still later, painters began to study the effects of highlights and reflected light.

Massive bodies seem to exist in their own space. When they are shown overlapping, the space is deepened and when some are shown higher than others, as in Polygnotos's paintings, there is a hint of the existence of space itself with figures set into it.

The idea of creating a sense of space in its own right seems to have been explored in painted stage sets in the fifth century BCE. Experiments with vanishing points (receding lines in architectural drawings that converge at a point) apparently even stimulated contemporary philosophers to make a theoretical study of perspective. Such, at any rate, is the testimony of Vitruvius, a Roman living in the first century BCE/CE, one of the writers from whom we derive much of our information about classical painting.

Man seated on his tomb flanked by two standing figures (lekythos)
The name of the painter is not known, c.410 BCE
Attic white-ground pottery, height
48 cm (18⅞ in.)
National Archaeological Museum, Athens

The white slip covering delicate funerary vases allowed for drawing that resembled what could be done on white-washed walls.

KEY QUESTIONS

What kinds of decoration are most appropriate when decorating
 pottery?

What are the advantages (or disadvantages) of using human
 figures to decorate pottery?

Are paintings better if they tell a story?

Detail of the seated
figure opposite

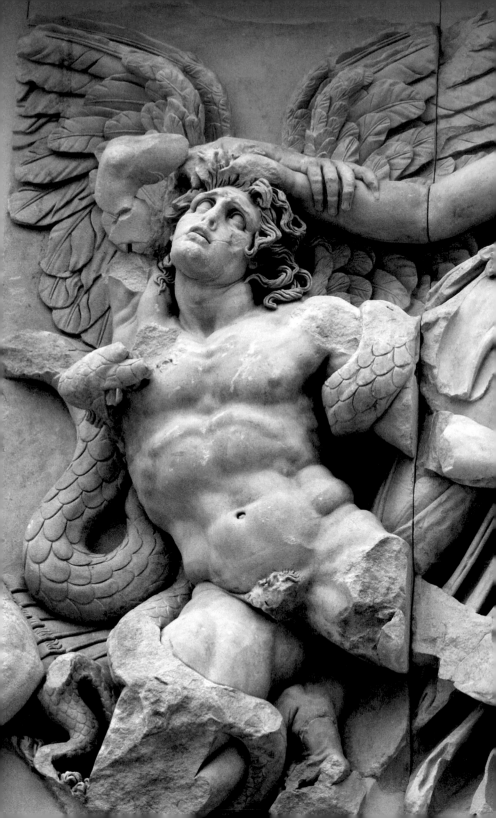

WIDENING HORIZONS: INNOVATION AND RENOVATION IN LATER GREEK SCULPTURE

-

Just as the conquests of Alexander the Great seemed at first to be boundless, so too did the possibilities and ambitions of Greek sculptors

-

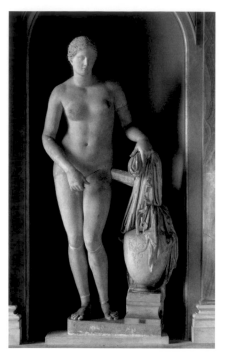

The classical solutions so ingeniously devised in the fifth century BCE did not prevent Greek sculptors from continuing to seek new challenges, create ever more complex compositions and widen their fields of interest for some centuries. Then they began to look backwards and gradually they lost their extraordinary flair for originality and innovation.

SOMETHING NEW

Around the middle of the fourth century BCE (around 350 BCE), Praxiteles made a revolutionary new image of Aphrodite. To show the love goddess in all her glory, he showed her entirely unclothed!

Poems were written to celebrate it, men fell in love with it

The male nude had long been accepted as a challenging subject for artists, but Praxiteles was the first to create a major statue representing, instead, a *female* nude. His Aphrodite made

Opposite, left:
Aphrodite of Knidos
Greek original by
Praxiteles in marble,
c.350–340 BCE
Roman copy
Marble, height
204 cm (80⅜ in.)
Vatican Museums, Rome

**The engaging warmth
and humanity of the
original statue is lost
in this crudely carved
copy lacking the delicate
colouring of the surface
that was one of the
charms of the original.**

Opposite, right:
Leda and the Swan
Drawing by Raphael
(after Leonardo da
Vinci), c.1507
Pen and ink over black
chalk underdrawing, 31 x
19.2 cm (12¼ x 7½ in.)
Royal Collection, Windsor

**Leonardo da Vinci's
drawing was made in
preparation for a painting
showing the mortal
woman Leda innocently
embracing the lascivious
god Zeus who was
temporarily disguised
as a swan.**

for the people of Knidos was extravagantly praised for its beauty, the melting glance of the eyes, the radiance and joyousness of the expression. Poems were written to celebrate it, men fell in love with it and an enthusiastic collector, the king of Bithynia, was so smitten with it that he offered to cancel the whole of the Knidian public debt (which was enormous) in exchange for it. But the Knidians wisely declined, for the image made the city of Knidos famous.

The original colouring made a great difference, giving a soft blush to the cheeks and the celebrated 'melting glance' to the eyes

The statue, unfortunately, has been lost, and it now requires a considerable feat of imagination to see what all the fuss was about, especially when looking at this uninspired Roman copy (opposite, left). The colouring of the original must have made a great difference, giving a soft blush to the cheeks and the celebrated 'melting glance' to the eyes. Praxiteles considered his finest statues the ones that Nikias had painted, and Nikias, himself a renowned painter of pictures, clearly did not feel that colouring Praxiteles's statues was beneath his dignity.

Even through the dull Roman copy, one can grasp something of the harmonious ease and self-containment of the original pose. Praxiteles has cleverly applied the Polykleitan invention of contrapposto to the female form. Notice the contracted side of the body (to our left), where the hip rises and the shoulder drops, while on the other side, the line of the torso is extended as the hip of the relaxed leg is lowered and the tense arm holding the drapery raises the shoulder. The sense of vitality and organic balance that made Polykleitos's Spear-bearer (pages 36 and 37, left) a classic work is equally effective here, but something new emerged when Polykleitan principles were applied to the sensuous softly rounded forms of the female figure.

This may be clearer in a Renaissance drawing (opposite, right). The contrapposto is much the same, but more obvious; the Praxitelean invention has been sensitively adapted. But like the Roman statue (opposite, left), this drawing is not an original. The original made by Leonardo da Vinci has been lost and in this drawing by Raphael we see only a copy – a copy, however, by a great artist.

The Knidian Aphrodite partakes of the naturalism characteristic of the fourth century BCE, naturalism not only of anatomy but also of context: Aphrodite is naked because she is preparing for a bath.

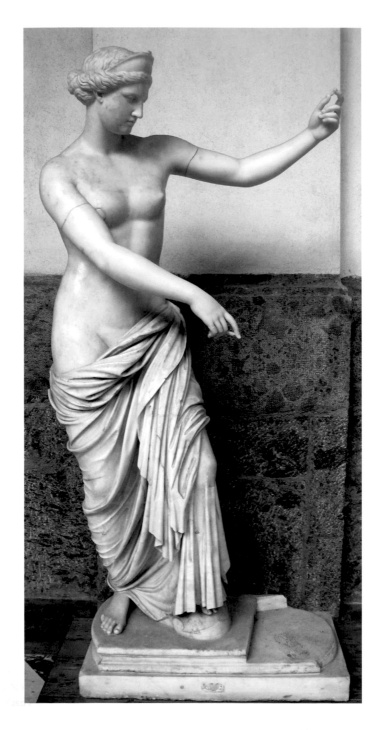

Aphrodite of Capua
Greek original
made in marble,
mid-4th century BCE
Roman copy
Marble, height
221 cm (87 in.)
National Archaeological
Museum, Naples

**The pose of this famous
statue was not only
copied in marble but
also used as decoration
in relief on small vessels
which reveal the position
of the shield she was
originally holding.**

The bath water is ready in the vessel to her left, the combination of discarded clothing and water jar supplying the necessary support for the extended left arm of the original. The inert fall of the soft drapery and the rigidity of the water jar contrast piquantly with the vibrant living forms of the body.

The goddess holds her right hand in front of her genitals. This could be interpreted as modesty, but, since this is the goddess of love, not any ordinary woman, the goddess may here be indicating the source of her power. Furthermore, her bath is no everyday wash but a serious ritual. This graceful integration of natural appearance and religious significance is one of Praxiteles's finest achievements.

If we imagine the poise and the radiant beauty of the Knidian Aphrodite as it originally was, we can begin to understand why, once the female nude had been portrayed in this way, the expressive pose was copied, varied and developed throughout antiquity and from the Renaissance to the present day. Though the female body came to be appreciated in art only in the fourth century BCE, its success thereafter became so great that eventually it virtually eclipsed the male.

**Through hints and partial concealment,
this Aphrodite was as erotic as any nude**

In addition to the wholly nude Aphrodite, a half-draped type was also invented in the fourth century BCE (opposite). We do not know the name of the artist who created the original of which the 'Aphrodite of Capua' (opposite) is a Roman copy. It portrayed the goddess revealing her naked torso as she holds a shield to her left and, in its reflection, admires her own beauty. The shield (now lost) served to keep the drapery in place, while at the same time functioning as a support for the extended arms. Through hints and partial concealment, this Aphrodite was as erotic as any nude, and the invention was enthusiastically copied with variations for centuries (see, for instance, page 95 and page 123).

FIGURES IN SPACE

The Spear-bearer of Polykleitos (pages 36 and 37, left) embodied the classic solution to the problem of presenting a figure satisfying from all four principal views and, at the same time, suggestive of movement. By the beginning of the third century BCE, this solution

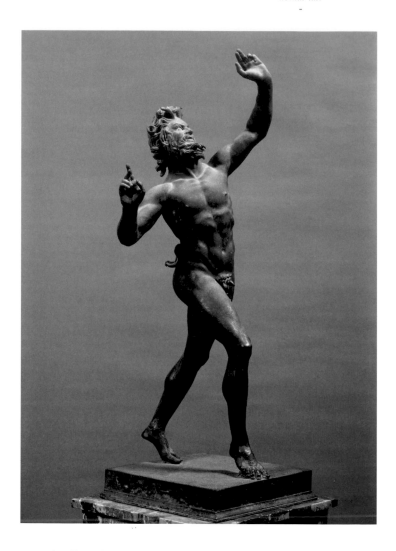

no longer seemed sufficiently challenging. Sculptors, particularly
those working in bronze, now wished to create figures that looked
beautiful from *all* points of view and led the eye (and the observer)
all round them. As if this were not difficult enough, the demands
of naturalism insisted that the resulting pose should be rationally
motivated, not just some arbitrary distortion for artistic purposes.

A work that seems both entirely natural and is also interesting
from all viewpoints is the Dancing Faun (above), a copy of a Greek
original from the early third century BCE. The joyous dance into
which this wild creature has thrown himself causes the body to
rotate into a dramatically twisted position.

Dancing Faun
Original in bronze,
early 3rd century BCE
Roman copy
Bronze, height
71 cm (28 in.)
National Archaeological
Museum, Naples

**Notice the position of the
upper arms, parallel with
each other to produce a
rhythmic pattern.**

A work that seems both perfectly natural and interesting from all viewpoints

The design (opposite) is extraordinarily effective from a variety of different angles. Not only is the movement convincing, but so too is the anatomy – far more than in the works of the fifth century BCE. Compare the head, with its combination of wind-blown hair, bony structure and soft pouches of skin, with the smooth head of the Spear-bearer, or contrast the sinewy body, with its careful distinctions of texture between muscles, fat and bone, with the body of the Spear-bearer, which relies chiefly on suggestive generalizations lacking in such specific detail (pages 36 and 37).

ALEXANDER THE GREAT AND HIS LEGACY

The conquests of Alexander the Great in the second half of the fourth century BCE (336–323) enlarged and changed the character of the Greeks' experience forever. Uniting the Greek cities with his own powerful Macedonian army, Alexander set out to requite the Persian Wars of a century and a half earlier. In a few short years he conquered not only all the lands that had previously belonged to the Persian empire but even much beyond. As Alexander and his army moved along, they founded cities on the Greek model, spreading both the use of the Greek language and a taste for Greek culture.

When Alexander died at the age of thirty-two, he left no adult heir.

Alexander's empire fell apart. Ruled by gifted successors and administered by a Greco-Macedonian elite, new Hellenistic kingdoms emerged, carved out of Alexander's vast conquests. They attracted artists from all over Greece and replaced the old Greek cities as cultural centres.

While the rulers of the larger kingdoms of Egypt, Syria and Macedonia squabbled with each other over territory, smaller kingdoms, like that of the Attalids in their capital at Pergamon, broke away and developed independently, some producing impressive works of art.

Meanwhile, the power of Rome had been growing. By 31 BCE the whole of this Hellenistic world had been absorbed into the Roman empire.

NEW CHALLENGES

Many Greek sculptors worked in the Hellenistic kingdoms. As before, the search for new problems provided a constant stimulus. By the middle of the third century BCE, naturalistic representation had been fully mastered and single figures could be designed with a multiplicity of satisfactory viewpoints. Now the challenge was to do the same thing with a freestanding group.

The Greeks had experience composing groups when they designed pediments (pages 48–55), but these were seen only from the front. A freestanding group of interlocked figures, visible from all sides, was quite another matter. Such groups became popular in the third and second centuries BCE and were often powerfully expressive as well as aesthetically satisfying.

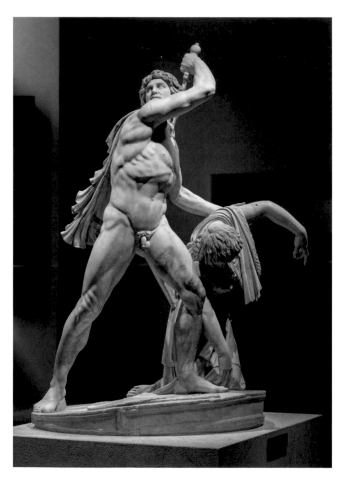

**Left and opposite:
Gaul about to kill
himself, having killed
his wife (Ludovisi Gaul)**
Original in bronze,
c.230–220 BCE
Roman copy
Marble, height 211 cm
(83⅛ in.)
National Museum of
Rome, Palazzo Altemps,
Rome

**The wrongly restored left
arm of the woman would
have hung nearly parallel
with her other arm in
the original bronze so
that the group would
have been roughly
pyramidal from several
points of view.**

The search for new problems provided
a constant stimulus

A group showing a defeated Gaul who has just killed his wife and is about to kill himself must have been magnificent in the original bronze. The Roman copy (opposite and below), even with some faulty restoration – the wife's left arm should hang parallel to her other arm – is still impressive. The group, roughly pyramidal, is complex, interesting and revealing from all sides.

But there is more than just artistic skill and formal achievement here; there is also a sense of drama and pathos.

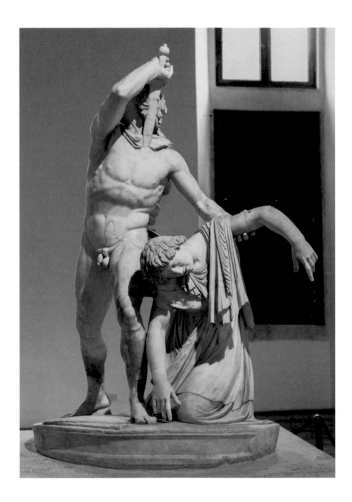

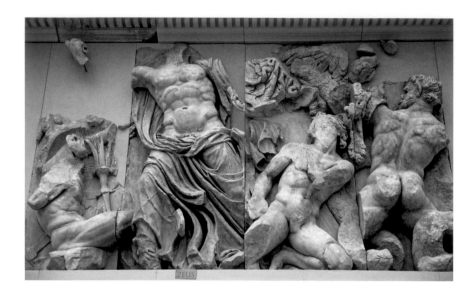

The group of the Gaul and his wife was set up by the Attalids in Pergamon as the central feature of a war memorial. The Attalids had recently repulsed an incursion of Gauls and were justifiably proud of their victory. They felt they had done as much to preserve Greek civilization as the Athenians had in the fifth century BCE when they had defeated the Persians, who, like the Gauls, were considered by the Greeks to be barbarians.

The Attalids' sense of triumph did not lead them to belittle the heroic enemy they had worsted. Respect for the enemy was part of Greek tradition and reached back as far as the Homeric epics, in which Trojan adversaries were portrayed as valiant and brave. Here, similarly, the Gauls are depicted as dignified and heroic.

The noble Gaul, who sees that defeat is inevitable, is too proud to submit. Only death will conquer him. He has killed his wife to save her from slavery. As she falls limply to the ground, he looks back, defiant to the last, and prepares to plunge the sword into his own throat.

The contrasts implicit in the scene – living and dead, man and woman, draped and nude – are dramatically accentuated. Notice how the lifeless feminine arm of the wife hangs beside the strong, tense, masculine leg of her husband.

The Gauls, who were tall and had thick hair and hard muscles, had very different physiques from the Mediterranean types they fought. Greek sculptors revelled in portraying the differences. This was part of the broader outlook that followed on Alexander's conquests.

Zeus battles giants
Part of the frieze of the Great Altar, Pergamon, c.180–150 BCE
Marble, height
342 cm (134⅝ in.)
Pergamon Museum, State Museums of Berlin, Berlin

The bulging muscles of the god and his swirling drapery lend visual drama to the physical conflict.

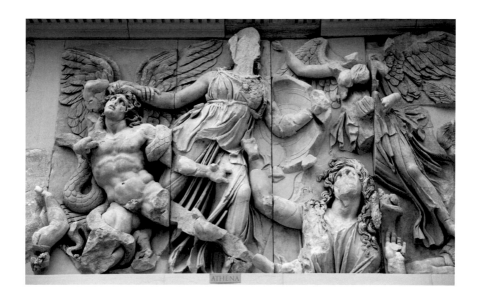

Athena battles giants
Part of the frieze of the
Great Altar, Pergamon,
c.180–150 BCE
Marble, height
342 cm (134⅜ in.)
Pergamon Museum,
State Museums of Berlin,
Berlin

**Athena's deeply carved
drapery accentuates the
power of her stride and
the force required to
subdue her enemy.**

The interest in naturalism, combined with the new interest in foreign types, gave rise to some of the most sensitive portrayals of northern Gauls, black Africans and South Russian Scythians that have ever been created.

The scope of art now greatly widened. Nude women, barbarians, old people, babies, the sick as well as the healthy, the ugly and the beautiful, even animals and monsters – all were considered challenges to artists and worthy of depiction. There seemed no limit to what skilful sculptors throughout the Hellenistic world could create and they produced an enormous number of statues ranging from the refined and elegant to the crude and vulgar.

NEW DRAMA IN OLD COMPOSITIONS

Half a century after the creation of the group of the Gaul and his wife (pages 90 and 91), probably between 180 and 160 BCE, the Attalids erected a still more elaborate commemorative monument in Pergamon. It took the form of a huge altar to the chief of the gods, Zeus, the base of which was decorated with a dramatic portrayal of the battle of the gods and giants (opposite and above).

The relief is extremely deep, and the figures almost seem to burst out of the background. Bulging muscles and swirling drapery convey a tremendous sense of explosive energy. A key episode, the first a visitor would first encounter, showed Zeus (to the left), his powerful body revealed as his drapery slips from his shoulder,

simultaneously fighting three giants (page 92), while Athena (to the right) turns back to dispose of another (previous page). The giants, who are getting the worst of it, are depicted with snake legs, or winged, or in ordinary human form. One falls to the left of Zeus and is shown in profile; another, smitten, collapses on his knees to the right, his body in a three-quarter view mirroring the three-quarter view of Zeus; a third (further right) rises on his snake legs to fight on and is shown in back view. The careful arrangement and variation of the positions of the figures is not immediately obvious, but it contributes to the effect of the whole. Actually, the arrangement is based on a fifth-century BCE Athenian relief and is not the only classical reminiscence in the work, as we shall see.

Athena, striding vigorously away from Zeus, seizes her adversary by the hair (previous page). His wings fill the upper part of the relief. He looks up at her with anguished eyes – a development of the expression of pathos and drama first explored in the fourth century BCE. To the right of Athena, the earth goddess Gaia, mother of the giants, rises up from the ground and, with painfully drawn brows, implores Athena to spare the life of her son. Athena is unmoved; a winged Victory, knowing the outcome, flies over Gaia's head to crown Athena.

It is a splendid and creative adaptation of a great work of the past

The dominant motif of Zeus and Athena, powerful god and powerful goddess, moving in opposite directions but turning back to look at each other, is the very composition (though reversed) used in the centre of the west pediment of the Parthenon (pages 54–5). The visual quotation, obvious to an observer in antiquity, would have underlined the claim of the Attalids to be the cultural heirs of the Athenians in the fifth century BCE. It is a splendid and creative adaptation of a great work of the past.

USES AND ABUSES OF THE PAST

In time, adaptations of past works became less creative, as if some of the fire had gone out of Greek artists. A characteristic creation of the second half of the second century BCE (150–100) is the celebrated Aphrodite from Melos ('Venus de Milo'; opposite). A half-draped figure of the goddess, she obviously combines the partial nudity and the pose of the Aphrodite of Capua (page 86)

**Aphrodite of Melos
(Venus de Milo)**
c.150–100 BCE
Marble, height
202 cm (79½ in.)
Louvre, Paris

The beautifully designed contrapposto of the torso and the turn of the head contribute to the handsome rhythmic organization of this figure as well as to her well-deserved popularity.

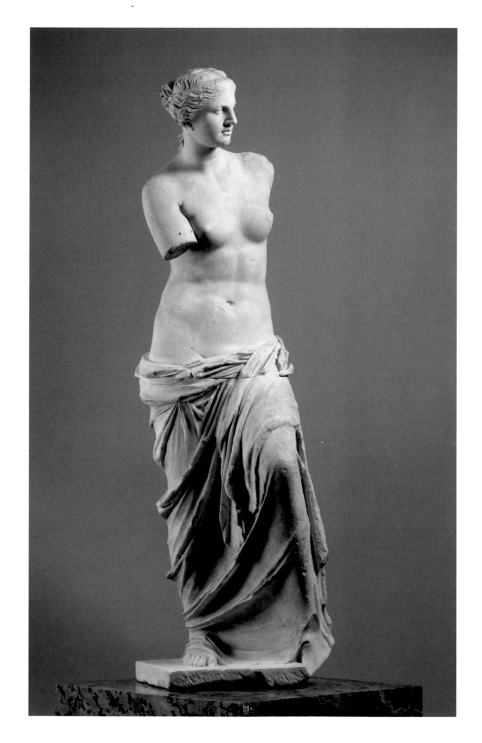

Orestes and Electra
1st century BCE
Marble, height
150 cm (59 in.)
National Archaeological
Museum, Naples

**This dull, static group
of conventional figures
serves to give ancient
sculpture a bad name.**

with the contrapposto and facial type of Praxiteles's Knidian
Aphrodite (page 84, left). The amalgam is successful, and the statue
is justly famous, but it is much more obviously derivative than the
Zeus and Athena on the Pergamon altar (pages 92 and 93).

The dependence of artists on the past grew heavier with time.
Imitations of older works became less creative. An example from
the first century BCE illustrates the sorry degeneration (above).
Two figures are combined to produce the group of Orestes and
Electra, mythological brother and sister. Orestes is modelled on
an early fifth-century BCE type of youth and Electra is practically
a copy of the late fifth-century BCE Venus Genetrix (page 43) with
slight variations – the right arm placed across the youth's shoulders,

and the drapery adjusted for greater modesty. It is a dry work, an unattractive pasting together of two unrelated older statues that makes the Aphrodite of Melos (page 95) look fresh and original by comparison.

It is but a short step from unimaginative adaptations like the Orestes and Electra to the production of exact copies of older masterpieces

The group is not worked out in terms of space and depth; the two figures are just strung out along a single plane. The front and back views are satisfactory, but the side views are virtually worthless. There was now a vogue, which continued with the Romans (or may have actually been promoted by them), for displaying statues against a wall, so that many groups (and even single figures) were designed for one view only.

It is but a short step from unimaginative adaptations like the Orestes and Electra (opposite) to the production of exact copies of older masterpieces. This had begun in the later first century BCE and was greatly stimulated by demand from Romans who had become thoroughly captivated by Greek art.

The Romans by this time had acquired control over all the Hellenistic kingdoms. They needed copies for decoration and display. The production of copies thus began to play a significant role in the economics and technique of Greek sculpture, and the Romans, as patrons, now called the tune.

KEY QUESTIONS

Is it important for freestanding statues to look good from more than one point of view?

Is it creative or unimaginative to use older works of art to convey new ideas?

Are there any limits to what sorts of subjects should be portrayed in sculpture?

PAINTING CAPTURES
THE VISIBLE WORLD:
FIGURES IN SPACE AND LIGHT

-

The Greeks gradually discovered ways
to create the elusive effects of light
and space in their paintings

-

Glorious paintings were created by celebrated artists in the fourth century BCE and later. Though much admired at the time, they, like so many other paintings, no longer exist. We can, however, get some idea of what paintings looked like in this period because we have reliable copies in mosaic and later Roman wall paintings. We even have one example possibly from the hand of a famous master.

Alexander Mosaic
Original probably a painting, early 3rd century BCE
Copy, end of the 2nd century BCE
Mosaic, 272 x 513 cm (107⅛ x 202 in.)
National Archaeological Museum, Naples

-

**Glorious paintings were created by celebrated artists
in the fourth century BCE**

-

INCREASES IN TECHNICAL MASTERY

By the end of the fourth century BCE, foreshortening of the body (both for humans and for horses) had been brought to perfection,

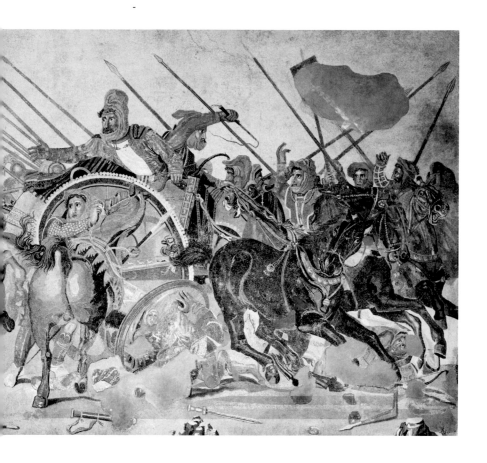

Although it has been damaged in parts, this excellent mosaic copy has miraculously preserved many characteristics of what must have been a brilliant work that captured the essentials of a world-changing conflict.

modelling in terms of light and shadow had been mastered, and the effects of highlights – and even reflected light – had been studied, the expression of emotion had been explored as well, and some rudimentary work on perspective had been done.

A reflection of all these achievements can be seen in a Roman mosaic that is a copy of a painting from the third century BCE (above). This mosaic was made in the first century BCE, when minute pieces of stone in a wide range of colours were available so that even a remarkably elaborate and subtle painting could be reproduced. This example, known as the 'Alexander Mosaic', copies a painting that glorified and dramatized Alexander the Great's victory over the Persian king Darius III.

Even though parts of the mosaic have been destroyed, we can still see how vividly it conveys a sense of the melee of battle, while at the same time keeping prominent the chief characters in this historical encounter.

101

The two kings oppose each other above the heads of the other figures. But there is not a moment's doubt who the victor will be

Alexander, helmetless, his hair blowing in the wind, rides forward energetically from the left. His head is clearly silhouetted against the sky. He has thrust his spear through one of Darius's devoted servants, who was just clambering off his horse when Alexander's spear pierced his side. To the right, another Persian nobleman has dismounted and holds the head of his restive horse. This chestnut horse is seen from the rear, superbly foreshortened with effective highlights glancing off his rump and some tentative shadows cast by his legs. Meanwhile, Darius looks back from his chariot and stretches out a compassionate hand towards his follower who is ready to die for him – an image that shows the characteristic Greek respect for the enemy. Darius's head and his vainly extended arm are silhouetted against the sky. He is the counterpart of Alexander; the two kings oppose each other above the heads of the other figures. But there is not a moment's doubt who the victor will be.

Darius's charioteer, to the right of the king, furiously whips the horses on to make a greater effort, careless that they may run down the fallen warrior whose back is to us, but whose face is reflected in his polished shield. The black horses of Darius's chariot gallop forward and to the right. Once again, the skilful use of highlights and foreshortening makes the complex arrangement clear.

It is remarkable that such subtlety of modelling and such evocative colour can be caught in the relatively crude technique of mosaic. The restricted range of colours may have been a characteristic of the original painting, as writers tell us that some painters at that time confined their palette to just four colours: red, yellow, black and white and, of course, mixtures of these.

While the technical achievements of painters up to the end of the fourth century BCE are splendidly revealed by the mosaic, so too are their limitations. The whole drama is acted out on a narrow stage, the depth of which is defined only by the foreshortening of the figures and their overlappings. The setting, too, has received short shrift: a few rocks on the ground and a single dead tree do for a landscape.

The Alexander Mosaic is very impressive; the creation of a great artist has been transmitted, with only slight loss of effect, through the skill of the mosaic copyist.

**Hades abducting
Persephone**
c.340 BCE
Wall painting,
height of frieze
100 cm (39⅜ in.)
Tomb I, Vergina

**The sureness of touch
and brilliant evocation
of conflicting
emotions reveal
the hand of a highly
distinguished painter.**

By contrast some of the paintings on the walls of the royal
tombs at Vergina in Macedonia have an incomparable immediacy
of impact. Such is the scene showing the god of the underworld
abducting the corn-maiden Persephone (above). The girl was
picking flowers with her friends when the god emerged from the
earth, seized her and carried her off in his chariot. A detail shows
the urgent god, his hair blowing wildly as he grasps the tender body
of the girl, her eyes anxious and her arms pathetically extended.
The freedom and power of the brush strokes, the certainty of the
effects, the intensity of emotion – all reveal the hand of a great
master. Such stature is seldom apparent in the paintings that have
come down to us from antiquity.

103

Street musicians
Original probably a
painting, 3rd century BCE
Copy signed by
Dioskourides of Samos
as mosaicist, c.100 BCE
Mosaic, 41 x 43 cm
(16⅛ x 16⅞ in.)
National Archaeological
Museum, Naples

An ordinary street scene
here provided the artist
with a subject in which he
could show off his ability
to suggest convincingly
three-dimensional figures
bathed in light.

NEW THEMES AND SETTINGS

The paintings from Vergina give us a glimpse of the quality of work that must have been produced by the best artists of the fourth century BCE, but it is only a glimpse. To learn more, we must rely on what the writers tell us and the evidence of Roman copies.

The range of subjects considered appropriate for painting broadened

The period after the conquests of Alexander the Great was one of expansion for the Greeks, not only geographically but also artistically and intellectually. Painting, like sculpture, showed both considerable technical advances and also a widening of themes. Earlier painting dealt mostly with mythological subjects and occasionally, as in the Alexander Mosaic, with historical events. Now, with artists showing greater interest in ordinary people, their everyday lives and everyday things, the range of subjects considered appropriate for painting broadened. A certain Peiraikos painted barbers' shops, cobblers' stalls, asses, eatables and similar subjects, earning himself the name 'painter of odds and ends'. Such a selection of themes, quite lacking in moral uplift, would hardly have appealed to Polygnotos. This expansion of acceptable themes meant that many unheroic subjects entered the painters' repertoire – vignettes of daily life, still lifes, flower paintings and representations of animals and birds – as well as the more usual men and gods.

By the end of the third century BCE, considerable advances had been made in creating the illusion of reality on a flat surface. A fine mosaic (opposite), which is a copy of a third century BCE painting, shows a group of street musicians (all wearing masks) and an unmasked boy, who may have played a mute part or just been an onlooker. The modelling of the figures is fully convincing, and the play of light is handled with consummate skill. Notice the accurate rendering of the cast shadow of the tambourine player as it falls on the pavement and then climbs up the wall; and notice the bright highlights and deep shadows on the shiny clothes of the musicians. The space above the players is generous, but depth is still restricted to a narrow shelf on which the action takes place.

The most famous mosaicist in antiquity was Sosos, who lived in Pergamon in the second century BCE. Among his celebrated works was one that represented doves drinking. A Roman copy of this work (appropriately in mosaic; overleaf) gives some idea of the

charm of the subject and the dignity that can be imparted even to such a humble theme. The copy, nevertheless, lacks one feature that was particularly praised in the original: the shadow in the water of the dove that has its head inclined to drink. A subtle effect indeed this must have been!

Probably around the middle of the second century BCE, artists became seriously interested in representing space in its own right, not just as the ambience in which people and things exist. Painted scenery for tragedies had already in the fifth century BCE stimulated an interest in perspective. The painter Agatharchos is supposed to have painted a perspective setting for a play and inspired contemporary philosophers to undertake a theoretical study of the subject. One suspects that the system of perspective was still rather haphazard, but by the first century BCE, when Roman painters copied and adapted Greek perspective settings (opposite), much progress had been made.

There was a vogue for painting architectural vistas in Rome during the first century BCE (opposite). Since these vistas, whether

Doves drinking
Original mosaic probably by Sosos of Pergamon, 2nd century BCE
Roman copy, 2nd to 1st century BCE or early 2nd century CE
Mosaic, 85 x 97 cm (33½ x 38¼ in.)
Capitoline Museums, Rome

Taking animals as the subject of an art work was one way in which the scope of art was broadened after the time of Alexander the Great. Still-lifes were now also considered suitable subjects for paintings.

they represent cities, palaces or sanctuaries, contain no figures, we may assume that they were inspired by stage sets, which in the theatre would have been populated by actors.

The wide tonal range of warm reds, glowing yellows, clear whites and tranquil blues helps to give a sense of depth (and distance)

City scene
From Room M, Villa of P. Fannius Synistor at Boscoreale, near Naples, c.50–40 BCE
Roman wall painting, room: 265.4 x 334 x 583.9 cm (8 ft 8½ x 10 ft 11½ x 19 ft 7⅛ in.)
Metropolitan Museum of Art, New York

The vision of a city full of houses transforms a wall into a vista.

A cityscape found at Boscoreale, near Pompeii, provides a charming example (below). A firmly shut door within a wall defines the front plane of this architectural painting. Above the wall one catches delightful glimpses of the city – a balcony jutting out to the right, an enclosed tower rising to the left, two houses between, with a ladder reaching to an upstairs window. In the distance, long colonnades stretch off to the right. Skilfully applied shadows within the wide tonal range of warm reds, glowing yellows, clear whites and tranquil blues help to give a sense of depth and distance, but it is the receding line of the buildings themselves that does most to suggest space.

The perspective, however, is neither unified nor consistent. Each element is foreshortened more or less independently, without regard to the whole. Such a piecemeal perspective scheme suggests that however evocative the Greeks made their architectural vistas, they never fully developed a single-point perspective such as was later formulated in the fifteenth century. This is what many scholars think, but others disagree. They believe that the Greeks had in fact mastered single-point perspective, but that some of the Roman copyists did not transmit their achievements accurately.

The figures are virtually lost in the breadth of the view

While depth in architecture can be indicated by means of receding lines, depth in landscape can only be suggested by means of subtle changes in colour with distance and the blurring of the farthest features. This is exactly what we see in the so-called *Odyssey Landscapes* (opposite). These are believed to be Roman copies of Greek originals illustrating episodes from the *Odyssey*, but they are very different from the seventh-century BCE vase showing a scene from the *Odyssey* (page 68), in which the figures are everything.

In the *Odyssey Landscapes*, by contrast, the figures are virtually lost in the breadth of the view. Odysseus's ships ride at anchor to the left of an intimidating landscape of huge boulders and rocky crags, where windswept trees perilously cling to stony surfaces. Standing before the opening of a dark cave, three men accost a woman with a jug. They are small figures, deftly drawn with swift, confident strokes. But it is the landscape itself – rocks, caverns, sea and sky – that dominates the scene.

Still life, landscape, portraiture, genre painting – all could now be rendered in paint

Painting was now as versatile as sculpture, as fully in command of all the resources of the medium. Painters during the second and first centuries BCE had learned how to represent space and light, and they had introduced new subjects. Still life, landscape, portraiture, genre painting – anything from lofty allegories to homely objects – all could now be rendered in paint. It was this

Land of the Laestrygonians
Detail from the
Odyssey Landscapes,
1st century BCE
Roman wall painting, 150
x 396 cm (58 x 155⅞ in.)
Vatican Museums, Rome

An extraordinary vision of a magical landscape dwarfs the figures who formerly provided the chief subject of Greek art.

richness in the range of themes and the mastery of technique that the Greeks bequeathed to the Romans.

KEY QUESTIONS

Should a painting always reflect the world of experience?

How important is it for a painting to look beautiful?

Why did it take so long to discover ways to suggest the world around us?

If the visual evidence comes from surviving Roman works, how can one be sure that the invention was originally Greek?

ROMAN SCULPTURE: ADOPTION AND ADAPTATION OF THE GREEK LEGACY

-

Ingenious sculptors working for the
Romans used the achievements of Greek artists
to serve their own particular needs

-

**Augustus from
Prima Porta**
c.20–17 BCE
Marble, height
204 cm (80⅜ in.)
Vatican Museums,
Rome

**Subtle modifications
of the classic poise of
the Spear-bearer have
made it possible to
show the emperor
Augustus as a dignified
and commanding
Roman worthy of his
exalted position.**

Artists working in the huge and efficient Roman empire created an immense amount of sculpture designed to satisfy specifically Roman public and private requirements. Within this abundant production, the Romans often found subtle ways to make use of the Greek achievements they particularly admired, thereby setting an example for all later times of how a classical tradition could be used in ever new contexts.

The Romans often found subtle ways to make use of Greek achievements

Though they thought highly of many aspects of Greek culture, the Romans were, by temperament and tradition, very different from the Greeks. While the Greeks enjoyed abstraction and generalization in thought and art, the practical, down-to-earth Romans preferred the specific and the factual. Sculptors, therefore, needed considerable ingenuity if they wished to adapt prized elements of Greek art for Roman use.

PORTRAITS

Greek portraits were almost exclusively of famous men and women: people who had won reputations as athletes, poets, philosophers, generals, rulers and orators. Something of the typical always clung about their portraits to help define the activity in which they had excelled. Roman portraits could be of anybody who had the money, family connections or distinction to order them. What the Romans wanted from a portrait was an accurate image of a particular person. Under the influence of Greek art, some sculptors working for the Romans might modify their style of portraiture and make their subjects look more beautiful or more powerful than they really were, but they never sacrificed their subject's unique features, the specificity so highly valued, to this end.

ROMAN PORTRAITS AND GREEK FORMS

An impressive portrait of the first emperor, Augustus (31 BCE– 14 CE), illustrates the sort of brilliant compromise a sculptor working to the orders of a Roman patron could achieve (opposite).

Polykleitos's Spear-bearer (see pages 35–7) was the acme of classical sculpture, and the Romans deeply appreciated the sense

of dignity and ease embodied in the carefully constructed pose.
It was therefore chosen to provide the framework for a portrait
of Augustus that was meant to convey to his subjects both respect
for his authority and admiration for his grace and control. But the
Greek statue could hardly be taken over as a model just as it was,
since it had several features that offended Roman taste.

The Spear-bearer was transformed into Augustus, the classical structure Romanized

First of all, the Spear-bearer was an ideal figure – perhaps an
imagined representation of the Homeric hero Achilles, but certainly
not the image of a real person. This had to be changed. The head
of the Spear-bearer was modified as much as necessary to capture
the actual features of Augustus, and yet left just smooth enough to
reflect the Spear-bearer's purity of form.

Second, the Spear-bearer was nude. This was, of course, natural
for a heroic Greek statue and furthermore essential to reveal the
harmonious contrapposto. But it might have seemed improper for
a Roman, especially one like Augustus, who posed as the guardian of
ancient traditions of propriety and sobriety. So the sculptor dressed
his imperial subject in armour and even gave him a cloak. The
armour was, however, made so form-fitting that, while decency was
preserved, the modelling of the torso still remained clearly visible.

Third, the Spear-bearer lacked focus and direction. It could
not be right for the Roman emperor to stroll so dreamily through
space. On the contrary, he should address his subjects directly
and dominate the spectators who stood before him. Only slight
modifications of the Spear-bearer's pose were needed to bring
this about: the head lifted and turned a little to look forward
and outward, and the right arm raised as if to issue a command.
Thus Augustus, by gaze and gesture, as if through the force of
his personality, controls the space in front of him.

The statue was placed against a wall, as was often the case with
Roman sculpture, and so all the emphasis is concentrated on the
front view. The sides are less carefully thought out than for the
Spear-bearer, and the back is not even fully finished. Perhaps this is
why the accomplished sculptor who carved this statue did not mind
destroying Polykleitos's contrapposto by raising the shoulder on the
same side as the raised hip. The balance of the torso is somewhat
obscured anyway by the armour and the cloak, and in the front view

Titus
c.80 CE
Marble, height
196 cm (77⅛ in.)
Vatican Museums, Rome

**Although the emperor
Titus is clothed in a
voluminous Roman toga,
the sculptor, using skills
acquired by the Greeks,
was able to make clear
the pose of the man
within the garment.**

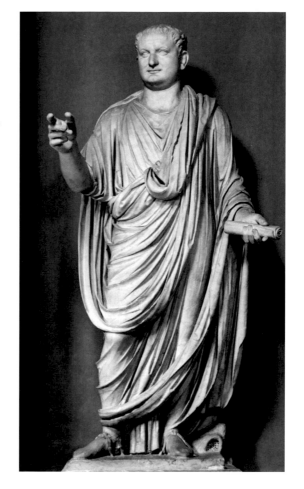

the curve of the raised arm responds handsomely to the relaxed
leg on the opposite side. The internal balance and self-contained
rhythm of the classical statue have been lost, but a new rhythm, one
which captured the authority of the imperial subject, was created.

Thus, the Spear-bearer was transformed into Augustus, the
classical structure Romanized. Enough of Polykleitos's invention
is preserved to give the image an air of naturalism and dignity,
while the modifications have turned it into a fitting image of the
first emperor. This was an inspired compromise, one that was
characteristic of the achievements of Roman art.

A portrait of the later emperor Titus (79–81 CE) seems more
emphatically Roman (above). Titus is shown wearing the traditional
Roman toga, a huge more-or-less oval garment that fell in a

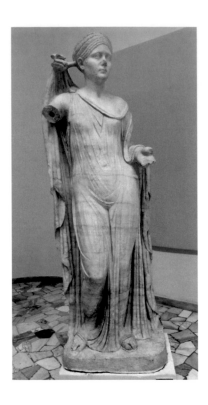

Empress Sabina as Venus
c.130 CE
Marble, height
180 cm (78⅞ in.)
Archaeological Museum,
Ostia

The Romans
often combined a
contemporary portrait
head with the body of a
classical statue, as here,
apparently considering
the meaning of the total
ensemble outweighed
the clashing styles of the
separate parts. The same
types of statues were
often used as supports for
different portrait heads
and sometimes a portrait
head would be replaced
with a new one, according
to political expediency.

multitude of voluminous folds and required considerable skill to
be draped properly. The specificity of characterization is marked.
No idealized Greek beauty tempers the crude features of the
emperor who, we may be surprised to learn, was considered
the darling of mankind and praised for his good looks!

Yet the lessons learned from classical Greek art have not been
forgotten or neglected. The technique of carving so as to reveal the
pose of the body through the way the folds of the drapery fall was
invented by sculptors of the fifth century BCE (compare the Venus
Genetrix, page 43, and the figures from the Parthenon frieze,
pages 62 and 120) and is used again here.

A further example of the persistence of Greek ideas and forms
is the portrait of Sabina (above), wife of the emperor Hadrian
(117–138 CE). The body of the statue is simply a copy of the fifth-
century BCE Venus Genetrix (page 43), but Roman modesty has
made the sculptor cover the left breast. The portrait head of Sabina
set on top of the classical image is a visual allegory. In Roman legend,
the goddess Venus was supposed to be the mother of Aeneas,
ancestor of the Roman people. The portrait of Sabina suggests that

she has the same maternal relationship to the Roman populace of the time as the goddess had in the mythical past.

Allegory is also an element in the superbly carved portrait of the cruel and maniacal emperor Commodus (180–192 CE; below). Commodus is draped in the lionskin of Hercules (the Latin name for Heracles) and carries the hero's club in one hand and the apples of immortality in the other (compare the Atlas metope at Olympia on page 57). Alexander the Great had been portrayed in the guise of Heracles, whom he claimed as founder of his line, and some of the Hellenistic kings had followed his example. Here, at a distance of half a millennium, a Roman emperor is doing the same.

The smooth surfaces of Commodus's skin are polished until they gleam, contrasting with the rich play of light and shadow in

Commodus as Hercules
Late 2nd century CE
Marble, height
133 cm (52⅜ in.)
Capitoline Museums,
Rome

**Rulers liked to be seen
as gods or heroes and
Commodus was not alone
in dressing up like a hero.**

the hair and beard. Heavy-lidded, immaculately groomed, with an
air of incontestable superiority, the emperor gazes out from beneath
his Herculean disguise. This brutal ruler acted out the hero's role in
hideous parody. Having collected all the legless inhabitants of Rome,
he fitted these unfortunates with snake-like trappings attached
to the stumps of their limbs, gave them sponges instead of rocks to
throw and slew them mercilessly in the arena, declaring that he was
Hercules punishing the obstreperous giants. This insightful portrait
(previous page), while preserving the official dignity of the emperor's
image, still manages to hint at the character of the perverted sadist
who occupied the position.

Detail of the procession
Part of the Ara Pacis
frieze, 13–9 BCE
Marble, height
160 cm (63 in.)
Ara Pacis, Rome

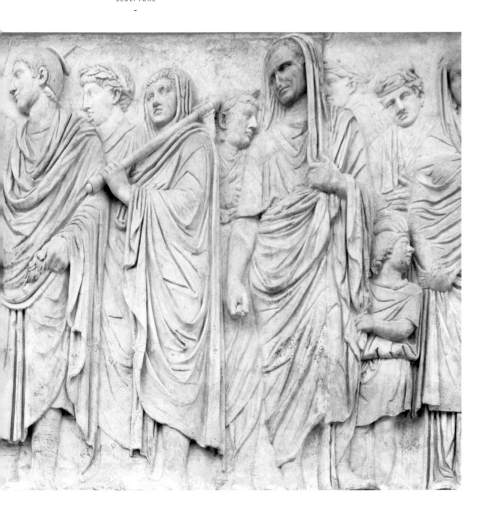

The Roman sculptor modified the classical style invented by the Greeks for the Parthenon frieze to suit Roman taste by recording a specific procession that took place on a specific day and including portraits of the most important people who participated at the time.

HISTORICAL RELIEFS

The craving for specificity seen in Roman portraits is also apparent in Roman reliefs. The most characteristic of these are the historical reliefs that were carved to decorate monuments erected to commemorate particular events (altars, arches and columns). Greek architectural sculpture (see pages 48–63) usually depicted timeless myths. Even the Parthenon frieze, which was in its own way commemorative, lacks the explicitness and specificity of person and event that was necessary and meaningful for the Romans.

The Altar of Peace (Ara Pacis; above) erected by Augustus (31 BCE–14 CE) demonstrates the Roman attitude. As was typical of Augustan art (see the Augustus of Prima Porta; page 112), Greek

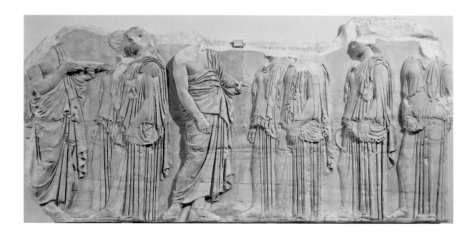

models were used to impart dignity and grace to the subject, but Roman ideas pervade the whole.

Detail of the procession
Part of the Parthenon
frieze, c.442–438 BCE
Marble, height
96 cm (37¾ in.)
Louvre, Paris

-

On the Ara Pacis recognizable portraits are carved and the procession itself can be dated to the day

-

The ability to show a group of girls in procession with authority and grace is one of the great achievements of the sculptors of the fifth century BCE, as seen here.

The altar enclosure was richly decorated with reliefs. Some of them showed a procession (pages 118–19), which called to mind the procession on the Parthenon frieze (above). The beautiful play of light and shade on the folds, the clear articulation of the bodies under the drapery, the wonderful sense of rhythmic progress – all these features owe much to the Parthenon frieze. But whereas on the Parthenon frieze individuals cannot be identified (see page 62) for several well-preserved heads, nor the exact moment be determined, on the Ara Pacis (pages 118–19) recognizable portraits are carved and the procession itself can be dated to the day (4 July 13 BCE) though the carving was not finished until four years later.

The uniqueness of the participants and of the event – it was the inauguration of the altar itself – is emphasized. The priests in front wear their special spiked hats, a man with veiled head follows them carrying the axe to kill the sacrificial animals, then comes the tall general Agrippa, to whose robes a timid child clings – all this is very different from the non-specific representations in classical Greek art.

The decoration on the Arch of Titus (opposite), like the portrait of Titus (page 115), seems less dependent on classical prototypes than do the reliefs and portraits carved for Augustus (pages 118–19

and 112). The panel showing Titus's soldiers carrying the spoils from Jerusalem is particularly vivid (below). Since Roman sculpture and relief, like Greek, was always coloured, the carvings representing the golden objects looted from the Temple in Jerusalem would have been gilded. Imagine how convincing this procession would have been when the soldiers' tunics were still brightly painted and the golden menorah (seven-branched lamp holder) glittered against a painted dark blue sky. Much space has been left uncarved above the heads of the figures, and this gives the impression that they have much freer movement in a more natural setting than the members of the procession on the Ara Pacis (pages 118–19), most of whose heads touch the confining top of the frieze.

-
The panel showing Titus's soldiers carrying the spoils from Jerusalem is particularly vivid
-

Triumphal procession of the spoils of Jerusalem
Scene from the Arch of Titus, c.81 CE
Marble, height
204 cm (80⅜ in.)
Roman Forum, Rome

The original colour applied to this relief would have made the triumphal procession seem extraordinarily vivid and real.

A totally different approach is used in the delicate low reliefs that decorate the great column celebrating the victories of the emperor Trajan (98–117 CE) over the Dacians (overleaf). Quite another sort of realism is used here, not the vivid visual realism of the Arch of Titus (below) but instead a kind of documentary, diagrammatic realism, that is, the abstract idea of what is taking place is

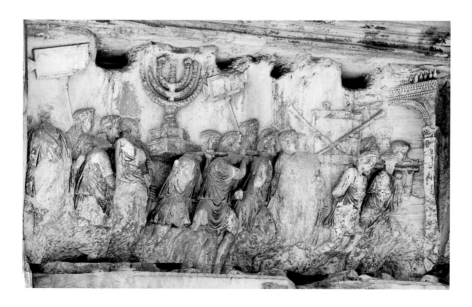

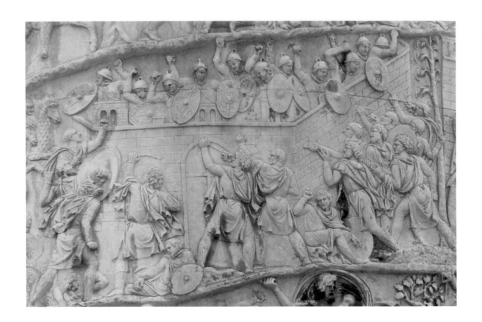

represented as it might be described in words rather than the way it actually would look to a person present at the time. Conceptual truth is preferred to the truth of what the eye sees.

Though perfectly intelligible, the whole scene in the above panel lacks visual logic

The Romans are confined within their well-built camp, beating off the attack of the barbarian Dacians (above). Light-armed Dacian troops carrying bows and arrows and slings threaten the camp from the front and the right. Helmeted Romans within the camp hurl missiles down on the besiegers from the top of the wall. Though perfectly intelligible, the whole scene lacks visual logic. The Dacians are seen straight on, but the camp from above. The walls of the camp have been made absurdly low so that the artist could focus attention on the interesting combatants. Had he tried to keep all the elements in correct proportion, he would have had to devote most of the space to the depiction of immense dull stretches of wall and would have had to make the men tiny.

The conceptual (as opposed to the visual) approach used on the reliefs on the Column of Trajan enables the artist to show complex

Barbarians attack the Romans within their camp
Scene from the Column of Trajan, 113 CE
Marble, height of narrative band c.100 cm (39⅜ in.)
Column of Trajan, Rome

In order to convey the scene of a tense battle that took place during Trajan's war in Dacia (modern Romania), the Roman artist sacrificed literal realism and a coherent point of view, instead combining a map-like bird's-eye view with figures seen head-on to ensure the setting of the conflict was clear.

action clearly by means of a certain amount of schematization. This seems very different from anything we have seen in Greek art, which insists on visual logic and consistency of presentation. Yet even within the brilliantly original carving of the Column of Trajan, tribute is paid to the fame and authority of Greek art. The interlude between the two campaigns that made up the Dacian Wars is marked on the column by the figure of Victory (below) inscribing Trajan's triumph on a shield. Does she look familiar? She is none other than the much-loved Aphrodite of Capua (page 86) dressed up for the part and equipped with wings.

Less than a century after the column decorated with reliefs was erected to glorify Trajan, another column was erected and carved in honour of the emperor Marcus Aurelius (161–180 CE; overleaf). Work on it continued throughout the reign of Marcus Aurelius's son Commodus (180–192 CE). Like the portrait of Commodus (page 117), the sculpture on this column is revealing; it is both more

**Victory writing
on a shield**
Scene from the
Column of Trajan,
113 CE
Plaster cast of marble
original, height
c.100 cm (39⅜ in.)
Museum of Roman
Civilization, Rome

**The Romans freely drew
on Greek prototypes in
order to make a point as
here where they adapted
a fourth-century BCE
figure of Aphrodite to
signal the victorious
outcome of the first
phase of Trajan's two
campaigns.**

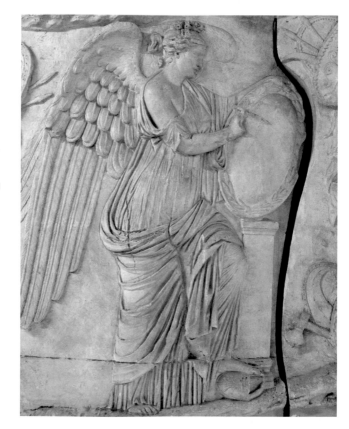

emotional and more expressive than the carvings on the Column of
Trajan (page 122). A characteristic relief (above) shows a massacre
of barbarians. A harsh and brutal contrast is made between the
armed and aggressive Romans at the top mercilessly stabbing down
on their unarmed foes and the helpless pleading barbarians, fallen
or dead. The man slightly to the right of centre who throws back his
arms and screams in horror captures the mood of the scene.

The relief is much more deeply cut than on the Column of Trajan
(pages 122 and 123) and is as deficient in subtlety of modelling as
it is in correctness of drawing (notice how unnaturally long are the
legs and body of the Roman at the left). The carving, though highly
expressive, has none of the smooth skill that was mustered for the
portrait of Commodus (page 117). Troubled times that were now
overwhelming the empire have affected the spirit of the people
and the sculptors working on the column. The work here heralds
the breakdown of style and decline in skill that were characteristic
of most sculpture (with the exception of portrait sculpture) during
the third century CE.

**Massacre of
barbarian captives**
Scene from the Column
of Marcus Aurelius,
180–93 CE
Marble, height of
narrative band
c.130 cm (51⅛ in.)
Column of Marcus
Aurelius, Rome

**The clumsy carving
of this scene is
compensated for by
its emotional impact.**

RELIEFS FOR PRIVATE INDIVIDUALS

Little official sculpture was produced for the state after the first quarter of the third century; the government had things to worry about other than the erecting of commemorative monuments. Between the years 235 and 284 over twenty emperors reigned, constantly threatened by usurpers. Only one died a natural death. Civil war plagued the empire, while at the same time the barbarians were hammering on the frontiers.

Many people hoped for better times in the life to come, and those who could afford it ordered elaborate carved coffins (sarcophagi) in which to have their bodies entombed. The fashion for burial in a sarcophagus had begun somewhat before the middle of the second century and grew considerably in the difficult period of the third century. Sarcophagi and portraits were almost the only kind of sculpture produced then.

Sarcophagi were decorated in several different ways. Sometimes the relief carvings on them illustrated Greek myths, sometimes Roman battles, sometimes typical incidents from the life of the deceased; sometimes they were ornamented with representations of the seasons, scenes of Bacchic delight or just lush hanging garlands.

Only a few of these sarcophagi are artistic masterpieces. They are, however, important for the history of art, as many of them survived from antiquity and were rediscovered in the Renaissance, when they were extravagantly admired and proved a great source of inspiration for artists.

A mid third-century sarcophagus (overleaf) that was much appreciated in the Renaissance depicts the story of Achilles and Penthesilea. Penthesilea was queen of the Amazons, a legendary band of warrior women. According to the myth, the Amazons were allies of the Trojans and came to fight beside them when the Greeks were attacking Troy. Achilles, the champion of the Greeks, fought the Amazon queen in single combat and killed her. His triumph, however, was hollow, for as she expired, he realized he had fallen in love with her.

The sarcophagus (overleaf) shows Achilles prominently in the centre holding the lifeless body of Penthesilea. Around them the battle continues to rage. Warriors, male and female, and their horses fill the entire height of the sarcophagus. Some of the figures are tiny, others are as large as Achilles. At either side a large Amazon flees but turns her head to look back. The two are mirror images of each other. Their formal symmetry, so at odds with the disorder of the battle, gives a clue to the principle of design used in the

carving of this sarcophagus: it is meant to be decorative. The artist
thought that enough of the story was conveyed by the central
group. He used the other figures as fillers, shrunken in size or
enlarged as necessary, in order to make the entire panel a rippling
surface of light and shadow. He was not interested in composing a
plausibly naturalistic scene or in telling a story convincingly. What
the artist was seeking was an overall decorative pattern not too
different in aesthetic aim from the geometric vase painted by a
Greek artist a thousand years before (page 66).

Most Roman sculpture was stimulated by Roman demands
for representations of particular people and events and this led
to remarkable new creations in portraiture and the carving of
commemorative reliefs. At the same time, the Roman appreciation
of Greek art manifested itself both in copying celebrated Greek
statues and in making sensitive adaptations of Greek art for

**Battle of Greeks and
Amazons centred on
Achilles and Penthesilea**
Sarcophagus,
late 3rd century CE
Marble, height
117 cm (46⅛ in.)
Vatican Museums, Rome

The central characters,
Achilles and Penthesilea,
in this mythological scene
are actually portraits of a
man and his wife and so
rather different from all
the other more idealized
and less specifically
characterized figures.

characteristically Roman subjects, an early example of artists
drawing on the classical tradition in a way that has persisted
ever since.

KEY QUESTIONS

Should a portrait show exactly how a person looks or should
 it suggest the sitter's character?

Were the Romans just being lazy when they adopted Greek
 forms in art?

Do you think historical reliefs are a good choice to
 decorate public monuments?

What do you think is the best way to commemorate
 historical events?

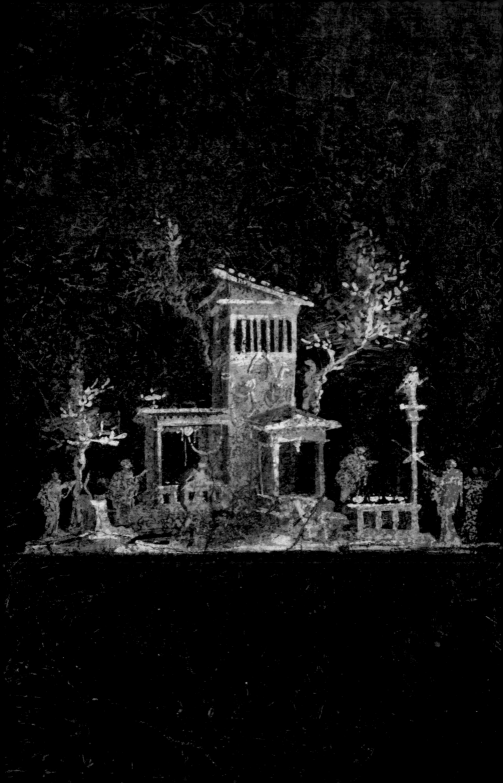

ROMAN PAINTING: USING THE INHERITANCE FOR DECORATION

-

The survival of an abundance of Roman painting
reveals the different ways that the decoration of rooms
could be organized

-

Perseus and Andromeda
From Pompeii, probably
a copy after a painting by
Nikias, c.340 BCE
Roman wall painting,
height 106 cm (41¾ in.)
National Archaeological
Museum, Naples

The sculptural quality of
the figures in this Roman
painting suggests that it
reflects a Greek painting
of the fourth century
BCE. Panel paintings
by celebrated artists of
this period were much
admired. Most of the
ones taken to Rome
were either dedicated
in temples and public
places or belonged to
the very wealthy.
Copies were popular
for the decoration of
more modest homes
and the same types
appear over and over
again in Pompeii.

The Romans admired Greek painting as much as they admired Greek sculpture. Those who could afford it, acquired original Greek 'old master' panels, while those who could not encouraged the artists they employed to make copies of particularly famous or popular works for them. The wall paintings opposite and below illustrate two examples. Single figures, groups and entire panel paintings were reproduced, adapted, spoiled or beautified according to the ability of the painters and the demands of the patrons.

This Greek heritage is, however stimulating, only part of the rich complexity of Roman wall decoration. While most Greek panel paintings have been lost, a great deal of Roman painting has survived. Most has come from the walls of private houses and public buildings in Pompeii and Herculaneum, two provincial but fashionable towns that were buried when Vesuvius erupted in 79 CE. Other paintings have been found in houses in Rome and occasionally elsewhere. It appears that the Romans used mural paintings in their homes more lavishly than did the Greeks, though, of course, this may be partly due to an accident of preservation.

The impression given by this abundant material is generally attractive, occasionally elegant and refined, at other times hasty and crude and occasionally just inept and vulgar.

Perseus and Andromeda
From Pompeii, probably a copy after a painting by Nikias, c.340 BCE
Roman wall painting, 110.5 x 103 cm (43½ x 40½ in.)
National Archaeological Museum, Naples

The Roman painter has modified the Greek prototype by painting in a more impressionistic style and adding two figures at the far left. Roman wall painters, presumably working mostly from pattern books, felt free to adjust their models to the taste of the time and the entire scheme of the room that they were decorating.

HOW ROMAN WALLS WERE DECORATED

As whole walls have been preserved in many cases, entire schemes of decoration can be appreciated as well as individual elements, and the changes in taste that modified these schemes can be observed over time.

Romans at first decorated their walls in the way that was common throughout the Mediterranean world during the second century BCE – hardly a matter of painting at all. They simply covered the wall with plaster painted and shaped to look like different kinds of marble slabs. This was supposed to make the whole wall appear as if it were veneered with expensive foreign marbles, which is presumably the way palaces were decorated.

**Once the idea of illusion had dawned,
a radical change took place**

Around the beginning of the first century BCE, some Roman decorators discovered that they did not have to go to the expense of making plaster blocks that protrude physically to give the impression

Room M
Villa of P. Fannius
Synistor, Boscoreale,
near Naples,
c.50–40 BCE
Roman wall painting,
room: 265.4 x 334 x
583.9 cm (8 ft 8½
x 10 ft 11½ x 19 ft 7⅛ in.)
Metropolitan Museum
of Art, New York

**The perspective in the
scenes decorating the
walls of this small room
is arranged so that the
entire complex is best
seen from the door.**

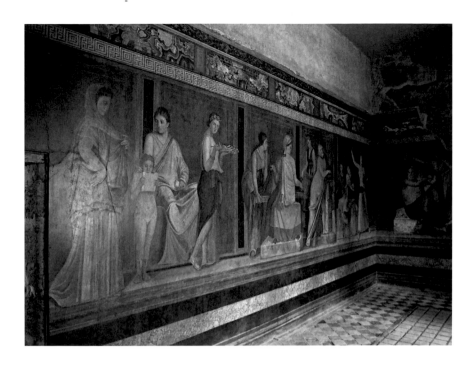

Part of the celebration of the Mysteries
Villa of the Mysteries, mid-1st century BCE
Roman wall painting, height of figure frieze 162 cm (64¾ in.)
Pompeii, near Naples

The three walls enclosing this room (and even the walls to the sides of the door) are decorated with impressively large figures enacting a ritual associated with the god Dionysus.

of three-dimensionality but could paint the wall illusionistically to give the same effect.

Once the idea of illusion had dawned, a radical change took place. If one could paint the illusion of protruding blocks of stone, why not paint the illusion of open windows and distant landscapes, people, animals, birds and gardens?

Thus was born a new style of wall decoration. It was an original Roman creation. Walls were painted to suggest that the confines of a room had been pushed back or that they had been entirely removed. Sometimes a colonnade was painted standing on a parapet through which one could see distant views (opposite); sometimes the parapet was a platform on which painted figures stood or sat (above); sometimes the whole space above the parapet was illusionistically opened up so that one seemed to be looking out at a charming garden (overleaf) as if there were no wall at all. The illusions were always rational and naturalistic, giving a plausible extension of space, and they were also delightfully varied.

A little room from a villa at Boscoreale (near Pompeii) was painted in this style with views mostly of architectural vistas (opposite). The lowest part of the wall, the dado, is decorated rather simply with stripes and imitation flat marble panels.

This is the part of the wall that might easily be obscured by
furniture or damaged when the floor was cleaned. Above it there
is a painted ledge on which some red columns appear to stand.
Between the columns there are symmetrical views of a city street
(one of which is illustrated on page 107) which flank an enclosed
sanctuary. Above the dado on the back wall there is an idyllic
landscape. Despite much formal symmetry, the vistas seem
perfectly possible, even though most (if not all) of the scenes
may have been derived from Greek prototypes.

Sometimes the illusionistic extension of the room does not
penetrate so far (page 133). In the celebrated Villa of the Mysteries
in Pompeii, the bottom section of the wall is treated the same way

Part of a garden scene
Villa of Livia at
Prima Porta, c.20 BCE
Roman wall painting,
height 200 cm (78¾ in.)
National Museum of the
Terme, Rome

**A delightful garden has
been created on the walls
of an underground room,
probably to charm diners
enjoying a cool meal in
the heat of summer.**

as in the little room in Boscoreale, but on the platform, instead of columns and a distant vista, there are large figures performing a ritual associated with a cult of Dionysus in front of a flat crimson wall. The realistic, nearly life-size, figures suggest a plausible presence and relate to each other – even across the space of the room – in an extraordinary way. At other times all the walls appear to open up to give a view of the garden beyond (above).

A CHANGE IN FASHION

This visually logical and plausible style began to pall by the last decade or so of the first century BCE and artists with sophisticated

patrons began to look for something different. This led to the invention of a new style of wall decoration, one that emphasized the flat confining nature of the wall, delighted in delicate, elegant details and outspokenly denied all appearance of rationality and logic.

-

This illuminated floating landscape accentuates the spatial ambiguity of the black wall

-

An enchanting example of this style comes from a villa at Boscotrecase (near Pompeii) that was owned by members of the imperial family and presumably shows the smartest, most up-to-date fashion. Above the dado there is an extremely narrow, illusionistically painted ledge on which two pairs of impossibly thin columns stand. The outer, sturdier columns hold up a delicate gable

Black wall with small floating landscape
From the imperial villa, Boscotrecase, near Naples, late 1st century BCE
Roman wall painting, 233.1 x 114.3 cm (91¾ x 45 in.)
Metropolitan Museum of Art, New York

A black wall does not visually define the boundaries of a room but leaves them indefinite. The effect is the same as a person would experience on a very dark night when no confining limits can be perceived.

Detail of floating landscape (see opposite)
From the imperial villa, Boscotrecase, near Naples, late
1st century BCE
Roman wall painting,
233.1 x 114.3 cm
(91¾ x 45 in.)
Metropolitan Museum of Art, New York

The vivid little landscape provocatively occupies its own space in the midst of the black spaceless nothingness of the wall.

from which pearls and gems seem to dangle. It is a sort of jeweller's architecture: rich, fanciful and exquisite. The inner columns support a fragile frieze that looks like an elaborately embroidered ribbon.

—
The landscape playfully foils any attempts at rational analysis
—

The rest of the wall (except for the dado) is painted black (opposite). This black background can be interpreted either as flat and limiting or as deep and spacious. In the centre of the wall, there is a tiny landscape (above). It is convincingly three-dimensional – the deft treatment of light gives a vivid impression of depth – but it floats in the air in a most unlikely manner. This illuminated floating landscape accentuates the spatial ambiguity of the black wall and playfully foils any attempts at rational analysis.

Other walls sport a central mythological painting surrounded by an implausibly delicate frame; sometimes the walls are interrupted by imaginary vistas of super-thin architectural members. These walls painted with large areas of flat colours combined with visually teasing decorative elements contrast with the plausible and convincing style that went before.

ANOTHER CHANGE OF TASTE

In 62 CE, when Pompeii was shaken by an earthquake and many houses had to be redecorated, most people had tired of the previous highly sophisticated taste. Once again they wanted paintings that created the illusion of space and appeared to open out the confining walls of their often very small rooms. Ambitiously, they also wanted to create a synthesis of the previous two styles combining comforting spaciousness with stylish elegance.

This theatrical vista is the equal of later Baroque painting

A room in the Pompeian House of the Vettii gives a good example of this composite style (below and 140–41). In the centre of each wall is a flat red panel framing a square painting (probably a copy of a Greek work). On either side of and above this red panel, the wall appears to be opened up to allow for a view into the distance. These expansive views are distinctly theatrical and in this differ from the everyday views of an earlier style. The side walls are treated the same way as the back wall, but, as they are longer (pages 140–41), there is space for an additional white panel. This panel is painted to look like a flat wall with a delicate border and a pair of figures floating in an unlikely manner in the middle, which like the black wall (page 136) can be interpreted either as airy space or as the physical wall that defines the limit of the room.

Ixion before Hera
Detail from a wall in the Ixion Room House of the Vettii, third quarter of 1st century CE Roman wall painting, Pompeii, near Naples (see pages 140–41)

**Theatrical/architectural
decorative panel**
From Herculaneum, near
Naples, 1st century CE
Wall painting, 170 x
185 cm (66⅞ x 72⅞ in.)
National Archaeological
Museum, Naples

**Astonishing tonal
gradations and vivid use
of theatrical perspectives
make this one of the
most spectacular images
preserved from a house
partially destroyed by the
eruption of Vesuvius.**

**Overleaf:
Two walls from
the Ixion Room**
House of the Vettii,
third quarter of
1st century CE
Roman wall painting,
Pompeii, near Naples

**A detail of one side wall
and part of the back wall
shows the conflicting
desires of the painter to
suggest that some spaces
are opened up and others
are flat and confining.**

This room gives an idea of the general level of painting at
Pompeii: cheerful but not particularly refined. The central pictures
are fashionable with themes drawn from Greek models, some
possibly filtered through pattern books, while flashy effects are
sought at the sides with the theatrical perspectives.

A fragment of a finer painting comes from another house, this
one in Herculaneum (above). The delicacy of the painting, the
sureness of tonal range and the bravura make this theatrical vista
the equal of the masterpieces of Baroque painting created sixteen
centuries later. It must have been placed fairly high on the left-hand
side of a wall-scheme like that in the House of the Vettii (opposite
and overleaf), judging from the angle suggested by the perspective

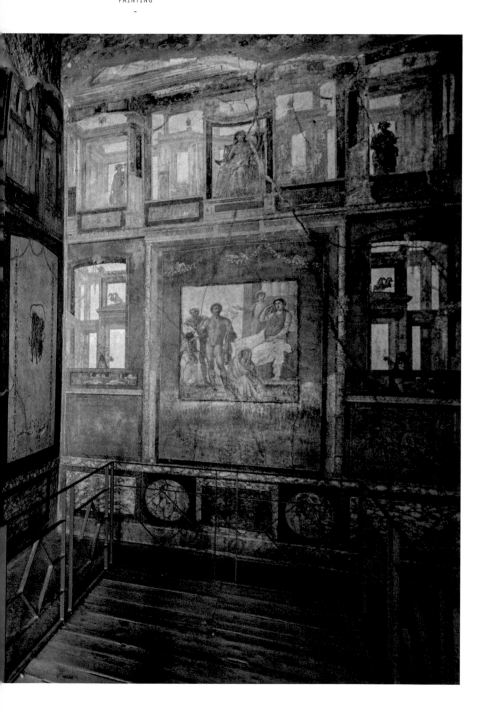

Riot in the amphitheatre
1st century CE
Roman wall painting,
height 195 cm (76¾ in.)
National Archaeological
Museum, Naples

**In order to make
the event entirely
comprehensible, the
Roman painter has shown
various features of the
scene from different
points of view, each the
most revealing of its
character: arena from
bird's-eye view, exterior
of the amphitheatre
head-on and even the
awnings that protected
the spectators from the
sun shown fully extended
at the top.**

because when painters decorated a whole room, they designed the perspective on each wall according to the way it would appear to a person standing at the door.

The abundance of surviving Roman painting gives us a vivid impression of the freedom and variety of the Roman imagination, drawing on a variety of sources of inspiration. Central framed 'pictures' reflecting celebrated Greek masterpieces are incorporated into ever changing imaginative decorative contexts.

A THOROUGHLY ROMAN PAINTING

Some paintings seem entirely untouched by Greek influence. One such is a lively portrayal of a riot in the amphitheatre in Pompeii (opposite). This was a real event: a fight broke out between the Pompeiians and visitors from nearby Nocera in 59 CE. So great was the disturbance that the emperor ordered the amphitheatre closed for ten years. The choice of subject is very Roman, as is also the visually illogical but intellectually lucid way in which the riot is portrayed.

The oval interior of the amphitheatre is seen from a bird's-eye view; the figures within it are seen head-on and overlarge. The exterior is drawn in a straightforward frontal view. The great triangle in front is the support for the flights of stairs that led over the top to the seating inside. The artist has helpfully turned the staircases outwards so that the steps can be seen. Actually, of course, they would not have been visible from the angle at which the rest of the exterior is shown. The whole picture reminds us of parts of the decoration on the Column of Trajan (page 122).

Painters did not cease to work after the eruption of Vesuvius in 79 CE obliterated Pompeii and Herculaneum. Walls were still painted throughout the Roman empire until people gradually began to prefer different kinds of decoration for their houses. But these later painted walls are seldom of the same quality as the earlier ones and are never again found in such abundance.

KEY QUESTIONS

Should the decoration on walls suggest space beyond the
 actual physical confines of a room?
If the light in a room comes only from the door, how should
 the decoration take account of this?
Is it a good idea to make pictures that are 'old masters'
 a central feature of a room?

UNITY AND DIVERSITY IN THE ART OF THE ROMAN EMPIRE

-

The huge geographic expanse of the Roman empire was matched by the diversity of the people and traditions that it encompassed

-

The enormous Roman empire comprised many different nations with many different traditions. People, ideas and even myths moved freely, travelling from one end of the empire to the other.

GREEK MYTHS IN THE ROMAN EMPIRE

Greek myths, along with other aspects of Greek civilization, had been absorbed into Roman culture well before the beginning of the imperial period and continued to be illustrated for centuries in paintings (pages 130–31), sarcophagi (pages 126–7) and mosaics (opposite and page 149) wherever cultivated Romans lived.

Discovery of Achilles among the daughters of Lycomedes
1st century CE
Mosaic
Pompeii, near Naples

The Greek story of how the young Achilles, dressed as a girl, had been hidden among the numerous daughters of Lycomedes, but revealed himself when he was tempted to take up the arms provided by the wily Odysseus, is told here economically with just three figures.

One such myth, which was surprisingly popular, was the story of the discovery of Achilles among the daughters of Lycomedes.

According to this tale, when the hero Achilles was still a boy, his mother, fearing lest he be conscripted to fight in the war against Troy, hid him among the fifty daughters of Lycomedes disguised as a girl. The Greeks, collecting forces for the expedition against the Trojans, knew Achilles was concealed there. As they also knew that he was destined to be a great warrior, they were anxious to recruit him. The problem was how to detect the beardless youth among the girls – without giving undue offence.

Greek mythology, along with other aspects of Greek civilization, had been absorbed into Roman culture

Ingenious Odysseus devised the following plan. He and a fellow Greek came to Lycomedes's court disguised as merchants. In this role they offered a range of feminine articles and also a spear, a shield and a sword, equipment fit only for a warrior.

The girls came and viewed the goods, the prettily dressed Achilles unrecognizable among them. What Odysseus then did assured him of his reputation for superior intelligence: he had a trumpeter sound the alarm. The girls responded with terror, but Achilles, his true nature rushing irrepressibly to the surface, immediately seized the weapons and so revealed himself – without causing embarrassment to anyone.

The scene of Achilles detected among the daughters of Lycomedes greatly appealed to the Romans. It was frequently painted on walls or used to decorate sarcophagi, and also appears in about a dozen surviving mosaics. Some show characteristics derived from the same model, but others display individual variants.

The Roman artist may well have found the juxtaposition of the nude woman and the male figure in drag pleasantly titillating

A mosaic found in Pompeii (page 146) depicts Achilles in the centre still clothed in his feminine attire, grasping a shield with one hand and a sword with the other. Odysseus, who laid the trap, approaches from the right, while Achilles turns to look at the astonished girl at the left, whose agitated gesture has displaced her clothing. She was not actually surprised to discover that Achilles was a man, for she was already pregnant with his son, but she was horrified at the consequences sure to follow upon this revelation. The Roman artist may well have found the juxtaposition of the nude woman and the male figure in drag pleasantly titillating.

A mosaic (opposite) from Zeugma is far more elaborate. The setting is a rich palace. Columns and other architectural features define the background. The scene is filled with excited figures: Achilles has grasped the spear in his right hand and, by the violence of his gesture, bared one unmistakably masculine breast, while a manly leg has been revealed as he strides forward. He has already fitted the shield to his left arm so that he seems ready for battle. Odysseus, to the right, cowers away from the raised shield, while Achilles' lover, decently clothed, her heavy cloak flying out behind her, tries to restrain the hero. The startled king, Lycomedes, rushes off to the left, while some of his numerous daughters crowd around behind the principals.

None of the mosaics is identical, but all are recognizable

These are just two of the many mosaics illustrating this myth found in places like Spain, North Africa, Cyprus and Palmyra, to name only a few. Some are restricted to the principal figures, as in the example from Pompeii (page 146), others have crowded scenes and elaborate settings like the example from Zeugma (opposite), a number even include the trumpeter, whose blast it was that actually stirred Achilles into action. None of the mosaics are identical, but all are recognizable. This myth is not in itself particularly significant, but what it reveals is the popularity of such stories as one of the elements in a common culture pervading the Roman empire.

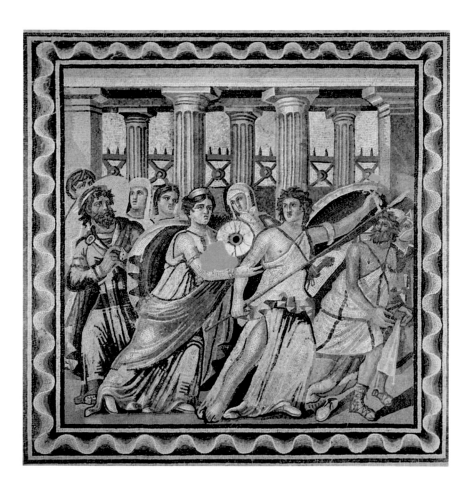

Discovery of Achilles among the daughters of Lycomedes
First half of the
3rd century CE
Mosaic, 175 x 171 cm
(68⅞ x 67⅜ in.)
Zeugma Mosaic Museum,
Gaziantep

This careful mosaic has placed the myth within an elaborate architectural setting recalling the palace full of girls in which Achilles was hidden.

NON-ROMAN ETHNIC TRADITIONS

Although Roman culture pervaded the empire, a variety of ethnic traditions were occasionally combined with Roman forms to produce something new. Such are the mummy portraits painted in Egypt during the Roman period. These solemn and beautiful images representing the deceased were placed over the faces of the dead once they had been mummified. Mummification was, of course, practised by the Egyptians from remote antiquity, and the practice was continued even after Egypt had been conquered, first by Alexander the Great and then by the Romans. Invaders married local women; populations became mixed – and so, too, did their art.

The extraordinary vividness of many of these images is due to the accomplished naturalism that had been developed over many centuries. In the portrait (opposite), for example, the clever touches of white highlighting the eyes, nostril and lower lip, the shading of the side of the nose and under the chin, and the subtle modelling of face and neck suggest a three-dimensional figure bathed in light.

Mummy portrait
c.160–70 CE
Encaustic on limewood
with gold leaf, 44.4 x
16 cm (17½ x 6¼ in.)
British Museum, London

This beautiful image makes use of all the realistic tricks devised by Greek painters. It was used as part of a mummy in the ancient Egyptian tradition.

-

The effects produced much resemble those of oil painting

-

This portrait was painted on wood using the encaustic technique, in which warmed (or emulsified) beeswax was employed as the medium to bind the pigments. The effects produced much resemble those of oil painting.

Most panel paintings created during classical antiquity were painted on wood and were lost when, in damp climates, the wood disintegrated. Since the dry climate of Egypt prevents wood from decaying, numerous mummy portraits have survived. Images like this one, with its engaging presence and subtle colour harmonies, are precious evidence of the heights Roman portrait painting could attain, even though this portrait was produced for a very un-Roman purpose.

Among the large and diverse peoples included in the Roman empire were some who had traditional practices that were markedly at variance with the prevailing culture. As long as these did not interfere with the efficient running of the empire, the Romans could be remarkably tolerant and even willing to make concessions to ancestral customs.

By the time the Romans came to power, Jews were no longer concentrated only in the area around Jerusalem but had been scattered throughout the Mediterranean and even to the east in

Mesopotamia, beyond the boundaries of the Roman empire.
In some places the Jewish population constituted a distinctive,
and occasionally resented, minority group. When conflicts erupted
and Roman mediation was involved, provided there was no real
threat to Roman authority, the Romans would usually protect the
Jews' right to preserve their religious rites and even excused them
from sacrificing directly to the emperor, allowing them instead to
make sacrifices in the Temple in Jerusalem *on behalf of* the emperor.

Diagram of the menorah
opposite

Local problems were dealt with locally, so that Roman tolerance
towards the Jews dispersed around the empire persisted even after
a great Jewish revolt was quashed with the sack of Jerusalem and
the destruction of the Temple in 70 CE (page 121), and two further
bloody uprisings in the second century CE had claimed thousands
of lives.

**The Jews of Sardis built an impressive synagogue, the scale of
which came as a surprise to the twentieth-century excavators**

By the fourth century CE, a sizable Jewish community had
been living in Sardis (western Turkey) for hundreds of years. Not
having been drawn into the rebellions against Roman authority, it
continued to flourish virtually undisturbed. The Jews of Sardis were,
therefore, able to build a large and impressive synagogue, the scale
of which came as a surprise to the twentieth-century excavators.
Many prosperous Jews made dedications to maintain the upkeep
of the synagogue, expressing themselves more often in Greek (the
local language in this part of the empire) than in Hebrew or Latin.

**The same techniques as the Romans used were employed
by the various minority sects**

In the fourth century CE, a certain Socrates dedicated a large
marble menorah (opposite). A fragment of his offering, with its
outstanding virtuoso open-work carving of a floral design between
the branches, has survived. (The reconstruction drawing suggests
how complex and elaborate it originally was.) This finely executed
but characteristically Jewish object (compare the picture on page
121, which shows the golden menorah looted from the Temple in
Jerusalem) is just one illustration of how the same techniques used

Menorah (seven branched lamp-holder)
First half of the 4th century CE
Marble, preserved height 56.6 cm (22¼ in.)
Synagogue, Sardis

This handsome dedication reveals the accomplished techniques for carving marble available throughout the Roman empire.

to produce the elegant stone carvings that graced so many Roman monuments were employed by the various minority sects that made up the huge heterogeneous empire.

ART OUTSIDE THE CLASSICAL TRADITION

The slow but brilliant progress of the Greeks in discovering ways to represent human figures in a lifelike manner and to fill spaces, however awkward their shape, with harmonious designs has been traced in previous chapters. These achievements were passed on to the Romans and used in their most urbane works (see pages 110–43). But not all artists were trained to meet such high standards. Even in Rome itself naïve compositions and ill-proportioned figures were sometimes created, and in the provinces many stone carvers who could manage to carve inscriptions extremely well were quite useless when it came to more sophisticated demands.

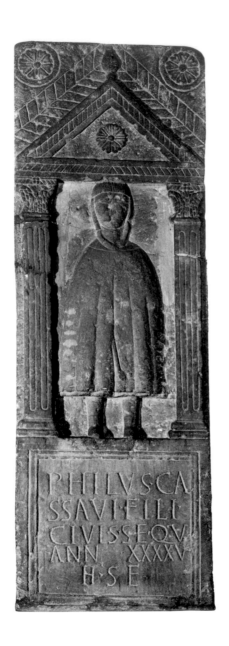

**Grave stele of Philus,
Cirencester**
Mid-1st century CE
Limestone, height
216 cm (85 in.)
Gloucester City Museum
and Art Gallery,
Gloucester

Such a naïve image by
a sculptor trained in
the carving of letters
but unaccustomed to
depicting figures reveals
how very difficult it is
to convey what a draped
human being actually
looks like.

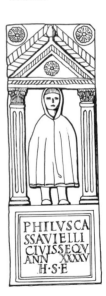

A tombstone from Cirencester in England displays well-cut Roman lettering and an architectural frame with fluted pilasters crowned with Corinthian capitals topped by a triangular pediment (opposite). Within this frame is the image of the deceased, Philus by name, wearing a hooded cloak in local style.

The heavy garment does not simply obscure his body; he seems to have no discernible body under it at all. His head emerges at the top and two lower legs and feet at the bottom, but as there is no hint of underlying anatomy, his legs might as well be hanging directly from his shoulders. Drapery, even rather heavy drapery (see Athena on page 57) or the procession on the Ara Pacis (pages 118–19), can be made wonderfully revealing of the body beneath – but it takes great skill and training to make it do so. The naïve artist here, who has got a good grasp only of the trimmings of Roman art, was clearly at a loss when it came to depicting a human figure.

The craftsman carver here had little idea of how to convey anatomy correctly

The tombstone for Philus was made for a private individual, but another example of work made outside the classical tradition comes from a public monument: the large triumphal monument erected in the time of Trajan (117–138 CE) at Adamklissi in Romania. Here a huge mound supporting a gigantic stone trophy was encircled near the bottom by a series of metope-like rectangles. The rectangles were filled with figured subjects: military combats, anxious civilians, groups of trumpet players or corps of standard bearers. In one poorly preserved scene (pages 156–7), two barbarians are attacking the Roman between them, while a dead body is stuffed in horizontally at the top left. The craftsman carver here had little idea of how to convey anatomy correctly, how to make action convincing or how to create a satisfying composition with figures all on the same scale. The skill and training that enabled Greek artists to fill metopes with bold and handsome designs were simply not available to him.

The carvings at Adamklissi, virtually contemporary with the Column of Trajan (see pages 122 and 123), provide an example of sculpture in and for the Roman empire untouched by the classical style so laboriously developed by the Greeks and enthusiastically espoused by the more sophisticated Romans. These awkward carvings, the product of workmen innocent of

the hard-won achievements of classical artists, dramatically reveal how unusual, refined and astonishing was the classical style evolved by the Greeks.

Within the vast Roman empire, Roman forms and ideals were often eagerly adopted, sometimes subtly modified, occasionally drastically transformed or even totally ignored.

But in time, after the fall of the empire, mighty buildings began to decay, marble veneers were stripped from walls and roofs fell in; statues were looted and burned to produce lime or melted down for their metal; paintings disintegrated and turned to dust.

And yet, even in ruins, the massive remains and eloquent fragments of what the Romans had built still astound the visitor and stir the imagination.

KEY QUESTIONS

Are there themes (or stories) in the modern world that
 are common (or recognizable) to everybody?
Is it patriotic to use traditional (or local) styles on
 public monuments?
What makes some artists abandon traditional styles?

**Panel from the Trajanic
triumphal monument
(Tropaeum Traiani)**
107–108 CE
Limestone, 150 x 120 cm
(59 x 47¼ in.)
Adamklissi

**Filling a metope-like
space with a battle scene
is a task quite beyond the
skill of an artist untrained
in the mystique of
representing human
figures convincingly.**

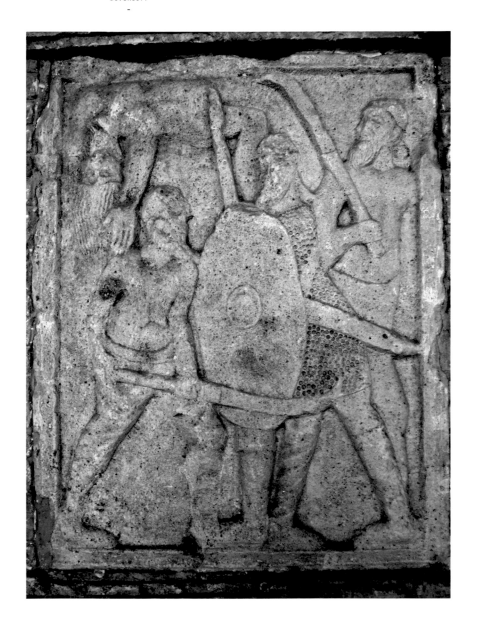

\-

A thing of beauty is a joy forever:
Its loveliness increases; it will never
Pass into nothingness . . .

\-

John Keats, *Endymion*, Book 1, lines 1–3
1818

GLOSSARY

Achilles: legendary hero of Homer's *Iliad*, acknowledged to be the greatest warrior among the Greeks. His parents, trying to prevent the boy from being recruited to fight at Troy, disguised the beardless youth as a girl and hid him among the fifty daughters of Lycomedes. Odysseus, by a clever ruse, induced him to reveal his true nature and took him to fight beside the Greeks. Achilles killed the bravest of the Trojans and the bravest of their allies who came to succour the besieged city, including Penthesilea, the queen of the Amazons. According to the legend, as she expired, Achilles himself fell in love with her. Achilles died not long afterwards, struck by an arrow in his only vulnerable spot, his heel (see also Trojan War).

Ajax: legendary hero of Homer's *Iliad*, the warrior who was second only to Achilles in the war against the Trojans. A good friend to Achilles during the war, he was the one who carried Achilles's body off the field of battle when he died (see also Trojan War).

Amazons: a legendary tribe of warrior women who were allies of the Trojans and sent an army under their queen Penthesilea to fight beside the Trojans (see also Achilles).

Aphrodite: (Roman equivalent: Venus) Greek goddess of love and beauty. Representations: Aphrodite of Knidos (Knidia); Aphrodite of Capua; Aphrodite of Melos; Venus Genetrix.

Athena: (Roman equivalent: Minerva) Greek goddess of wisdom and crafts, protector of heroes, patron of Athens.

Black figure: technique of vase painting in which the figures are drawn in black silhouette, details and inner markings are incised and touches of white and purplish-red are added.

Classical: term referring to the period in Greek art from about 480–404 BCE, in which a harmonious (but not insipid) balance between abstract beauty and realism was achieved. The art of this period is often considered an exemplar or model of excellence.

Classical antiquity: term referring generally to the art and culture of Greece and Rome from the eighth century BCE up to the introduction of Christianity as the official religion of the Roman empire in 313 CE.

Contrapposto: the pose of a human figure in which the weight
is on one leg while the other is relaxed and symmetry is avoided.
The axis of the shoulders slopes in one direction and the axis of the
hips in the other, so that the line of the torso on the side of the
weight leg is shortened and the torso on the side of the weightless
leg is correspondingly extended to produce the impression of
responsive organic balance.

Encaustic: painting technique in which warmed (or emulsified) wax
is used as the medium to bind coloured pigments.

Discus-thrower: celebrated bronze statue by Myron, known only
though numerous Roman copies.

Foreshortening: the apparent shortening of the form of objects
in relation to the angle from which they are observed; perspective
applied to single objects or figures, as when a horse is seen from the
rear and consequently appears foreshortened.

Frieze: a long, horizontal band carrying a continuous decoration
either in relief or paint.

Genre picture: representations of everyday life (as opposed to
mythological or historical pictures).

Giants: mythical sons of the earth goddess Gaia, who waged war
against the Olympian gods and were defeated by them with the
help of Heracles, often represented in architectural sculpture
(for instance, the Corfu pediment and the Great Altar at
Pergamon). The emperor Commodus pretended to be Heracles
fighting Giants in a hideous parody of the myth.

Hellenic: a term used by the ancient Greeks to describe themselves.

Hellenistic: a modern adjective used for the period from the death
of Alexander the Great in 323 BCE to final Roman acquisition of
all the lands ruled by his successors with the defeat of Cleopatra at
Actium in 31 BCE.
 After the death of Alexander, his conquests were divided up
by his generals. By 275 BCE three major dynasties had emerged:
the Ptolemies in Egypt, the Seleucids in western Asia and the
Antigonids in Macedonia. These rulers took on the title of king
and their vast kingdoms came to replace the old Greek city-states

as cultural centres. Other smaller kingdoms appeared at the edges of Alexander's conquests, for instance in Bactria (modern-day Afghanistan) and the Punjab. From the early third century to the later second century BCE, the Attalids carved out a domain for themselves centred on their capital at Pergamon. This became the Roman province of Asia after the last of the Attalids had bequeathed his kingdom to Rome in 133 BCE.

Hellenistic culture (and the Greek language) remained strong in the eastern parts of the Roman empire even after political independence had been lost.

Heracles: Herakles in Greek spelling (Roman equivalent: Hercules). Greek legendary hero whose deeds were illustrated on the metopes at Olympia, and who was imitated in cruel charade by the emperor Commodus.

Kouros: a conventional name for a statue of a nude young man, standing upright with one foot advanced and the weight evenly distributed on both legs, made in Greece between the late seventh century BCE until the beginning of the fifth century BCE (the Archaic Period). The frontality and symmetry of these figures was rejected in the succeeding Classical Period when an organic balance was preferred as the organizing principle for standing figures.

Menorah: seven-branched lamp-holder (part of Jewish tradition). A golden one was looted by the Romans from the Temple in Jerusalem; a marble one was found at Sardis.

Metopes: stone (or terracotta) panels alternating with triglyphs in Doric architecture. These were sometimes carved, as on the porches in the Temple of Zeus at Olympia and on the exterior of the Parthenon.

Modelling: (in painting) technique for rendering the illusion of volume on a two-dimensional surface by means of shading; (in sculpture) rounding forms in three-dimensions rather than just carving lines on the surface, for instance contrast between the treatment of the youth in New York and the one from Anavyssos (pages 12, left, and page 18).

Mosaic: technique for making a picture or design out of small pieces of stone or glass of different colours. The stones (called 'tesserae') are usually cut to be four-sided; glass is used sparingly on floors

but much more abundantly on walls and ceilings to provide colours like brilliant blue and gold that were not available in natural stones.

Odysseus: (Roman equivalent: Ulysses) legendary Greek hero of Homer's *Odyssey*, in which his adventurous journey home from fighting with the Greeks in the war against Troy is chronicled, including his encounter with a one-eyed, man-eating Cyclops. He was reputed to be the cleverest of the Greeks and succeeded in discovering Achilles when he was disguised as a girl among the daughters of Lycomedes (see also Achilles).

Pediment: triangular end of a gabled roof which could be filled with sculpture either in relief or freestanding.

Persian Wars: the wars fought by the Greeks to resist the aggression of the Persian empire. In 546/5 BCE the Greek cities on the coast of Asia Minor came under the rule of the Persians. In 499, Miletus, one of these cities, revolted and called on the Greeks in the mainland for support. Athens and one other city (Eretria) responded and succeeded in burning the regional Persian capital at Sardis. In reprisal, Darius the Great, the Persian king, sacked Miletus and sent a punitive expedition against the two Greek cities, first sacking Eretria and then moving to attack Athens. This force was defeated on the plain of Marathon in 490 BCE. In response, Xerxes, Darius's successor, assembled a huge force both on land and at sea to punish the mainland Greeks. Its successes culminated in the sacking of Athens in 480 BCE, but, at the same time, the Persian navy lost the sea battle off the island of Salamis and most of the army scurried home. The remaining Persian land forces were finally defeated by the combined Greek armies at Plataea in 479 BCE.

Alexander the Great's expedition against the Persian empire began on his accession in 336 BCE and was claimed to be in revenge for the Persian attack of 150 years earlier.

Perspective: a technique for painting scenes that appear three-dimensional on a two-dimensional surface to give the illusion of objects existing in space.

Priam: legendary king of Troy (see Trojan War).

Red figure: technique of vase painting in which the figures are left in the natural colour of the fired clay and the background and details are painted black with a brush.

Relief: sculpture in which figures remain attached to the background, either very deeply carved (high relief) or shallowly carved (low relief).

Sarcophagus: coffin, sometimes made of carved marble.

Signature (on vases): signatures appear sporadically on Greek vases; those accompanied by the word *egrapsen* (drew it) are presumably those of painters; those accompanied by the word *epoiesen* (made it) are presumably those of the potters. The artists who sign both *egrapsen* and *epoiesen* probably both made and painted the vase in question.

Spear-bearer: celebrated bronze statue by Polykleitos, known only through Roman copies, standing in contrapposto and illustrating Polykleitos's theory of proportions.

Torso: what is left of the human body when head and limbs are removed.

Treasury: small building in a Greek sanctuary built as a repository for offerings to the gods.

Trojan War: legendary war in which the Greeks fought to capture the city of Troy and regain the beautiful Helen who had been abducted by a Trojan prince. The story of the war and its heroes (Achilles and Ajax were the leading Greek warriors) and the final brutal sack of Troy was a constant inspiration to Greek art and literature and finally was even incorporated into the mythical history of the Romans.

White ground: a vase covered with white slip on which the decoration was either in black-figure or in outline, sometimes with colours that could not be fired added after firing.

Zeus: (Roman equivalent: Jupiter) Greek chief of the gods. Representations: bronze Zeus found off the coast of Artemisium (known as the Zeus of Artemisium), early fifth century BCE; Zeus fighting Giants, relief on the Great Altar at Pergamon, first half of the second century BCE.

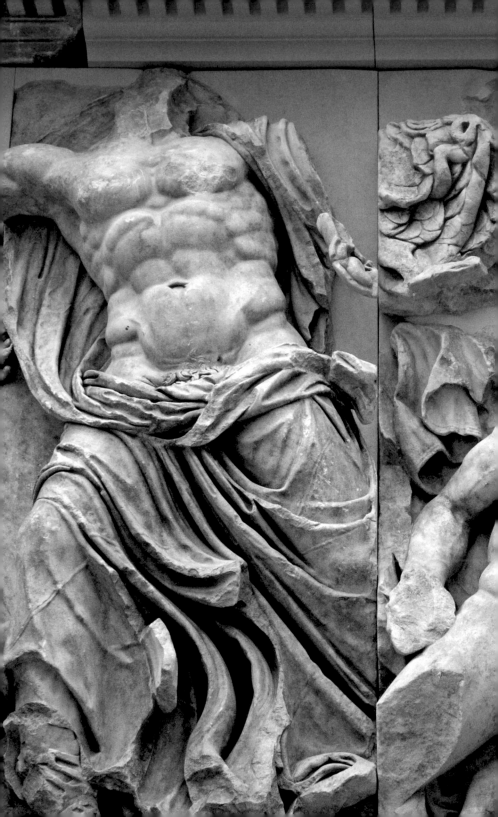

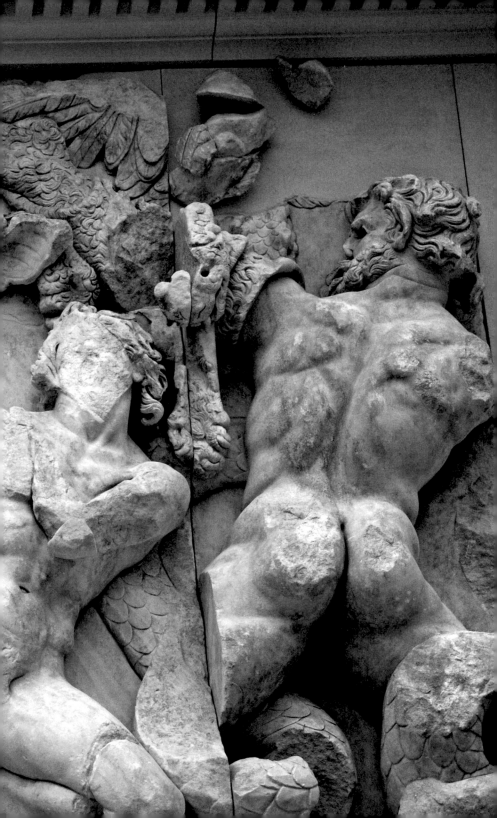

1100–1000 BCE

- A series of natural and man-made disasters lead to migrations by Greek-speaking peoples to the west coast of Asia Minor, the islands of the Aegean and mainland Greece.

776

- First Olympic Games

753

- Foundation of Rome

c.650

- First large-scale Greek sculptures in marble

c.610

- Black-figure technique in vase painting begins.

580

- Temple of Artemis in Corfu

530

- Red-figure technique in vase painting is invented.

490

- Persians attack Greece (Athenians defeat Persians at Marathon).

480

- Second Persian attack on Greece; Sack of Athens (Persians defeated at Salamis)

470–450

- Discus-thrower, Zeus of Artemisium

470–456

- Temple of Zeus at Olympia

450–420

- Polykleitos's Spear-bearer

447–432

- Parthenon built and decorated.

c.340

- Praxiteles's Aphrodite at Knidos

336–323

- Alexander the Great conquers the erstwhile Persian empire and even goes as far as the steppes of Russia, Afghanistan and the Punjab.

323–30

- Hellenistic period

306–304

- Three of Alexander's most able generals divide up the core of his empire: Antigonus taking Greece and Macedonia, Ptolemy, Egypt and North Africa, and Seleucus, Asia (the Asian countries that are part of the modern Middle East). Each assumes the title of king and becomes the founder of a dynasty (Antigonids, Ptolemies and Seleucids).

263–241

- Pergamon becomes a kingdom independent of the Seleucids.

238–227

- Attalus (of Pergamon) fights against the Gauls (Galatians) and assumes the royal title.

211

- Romans conquer Syracuse and bring home Greek art works in triumph, beginning their fascination with Greek art.

c.197

- Beginning of Roman involvement with the Hellenistic kingdoms, which are gradually absorbed into the Roman empire.

166–159

- Great Altar at Pergamon

133

- The last king of Pergamon bequeaths the kingdom to Rome

31

- Battle of Actium. Octavian (later known as Augustus) defeats Anthony and Cleopatra VII, the last of the Ptolemies.

30

- Egypt is annexed to Rome, completing the Roman takeover of the Hellenistic kingdoms.

27 BCE–14 CE

- Augustus becomes Roman emperor.

13–9

- Ara Pacis, Rome

c.30–33
- Crucifixion of Jesus Christ

70
- Romans destroy the Temple in Jerusalem.

79
- Eruption of Vesuvius (destruction of Pompeii and Herculaneum)

79–81
- Titus emperor

96–117
- Trajan emperor

101–106
- Trajan's conquest of Dacia (modern Romania)

113
- Column of Trajan, Rome is completed.

107–8
- Tropaion Traiani, Adamklissi, Romania

117–38
- Hadrian emperor (husband of Empress Sabina)

161–80
- Marcus Aurelius emperor

180–92
- Commodus emperor
- Commodus erects the Column of Marcus Aurelius in memory of his father.

235–84
- Numerous contenders to be Roman emperor
- Sculpture is largely confined to sarcophagi and outstanding portraiture.

313
- Emperor Constantine proclaims an edict of toleration for all religiouns. It bans the persecution of Christians and paves the way for Christianity becoming the official religion of the Roman empire.

330
- Capital of the empire moves from Rome to Constantinople.

WRITTEN SOURCES OF INFORMATION

Confronting what is left of Greek and Roman art is like entering a chaotic museum where most of the exhibits have no labels and the labels that do exist have all been thrown helter-skelter into some barely sorted piles. We have the remains of works of art – buildings, sculptures, paintings, vases, mosaics – seldom with any indication as to how they were made, by whom, or for what purpose.

Fortunately, apart from these physical objects, we have some written sources of information: histories, biographies and inscribed stones. The literary works lack illustrations, and the inscribed stones – often naming the dedicator and the artist – are usually only bases that once supported statues that are now lost. An important task in trying to understand Greek and Roman art is to attach what has survived in written records to what has survived physically.

Some helpful authors

Many ancient authors make incidental mention of works of art. For instance, Vitruvius, living in the time of the Roman emperor Augustus, who ruled from 31 BCE to 14 CE, wrote a book on architecture in which he discussed the painting of his time and referred to the earlier experiments with perspective made by Agatharchos (page 106). Others also give us snippets like Aristotle, who in analysing poetry in the fourth century BCE, compared the style of some poets to the style of some artists; or Josephus, who late in the first century CE, described the loot the Romans carried off from the sack of Jerusalem in 70 CE.

Two ancient writers, however, stand apart of the rest and give us more than just snatches of information.

The first is Pliny the Elder. He was a Roman polymath, interested in everything. (The breadth of his intellectual curiosity finally killed him, for he died while investigating the cataclysmic eruption of Vesuvius in 79 CE.) He wrote an encyclopaedic book, *Natural History*, which was a descriptive work divided into sections on animals, vegetables and minerals. In part of the section on minerals, he dealt with the stones and metals used by sculptors and the pigments used by painters made from minerals, and this led him to give a short history of sculpture and painting. Pliny discussed the development of the arts, the contributions of different artists and some celebrated individual works.

The second major source of information is Pausanias. He was a Greek traveller who lived in the second century CE and wrote a guide to Greece addressed to the tourists of his time. He walked through

the most important cities and sanctuaries in mainland Greece, noting things of interest and describing famous works that he saw. He devoted long passages to paintings by Polygnotos, and it was from his descriptions that modern scholars realized that Polygnotos set some figures higher in his paintings than others and were able to recognize that certain vase paintings were reflections of his work.

Such authors tell us a great deal about sculpture and painting. Much of their information came from Greek sources dating from the fourth century BCE or earlier. By then the Greeks had realized that in their art they had created something entirely new and noteworthy and were eager to comment upon it. Even as far back as the sixth century BCE, some architects had written about their work and we know that the sculptor Polykleitos in the fifth century BCE wrote a treatise explaining the principles on which he made his Spear-bearer (page 36 and page 37, left), but it was only in the fourth century BCE that actual histories of art were written and many anecdotes were recorded about artists. Unfortunately, most of this material is lost, but the fragments preserved by Pliny, Pausanias and other later authors give us valuable insights we could not obtain elsewhere.

Even so, we learn disappointingly little about the lives and personalities of artists.

Texts that identify and date works of art

Plutarch, who lived in the first and second centuries CE, wrote a biography of the Athenian statesman Pericles in which he mentioned the buildings that were erected under Pericles's influence. Among them was the Parthenon (Plutarch, *Life of Pericles*, 13, 31). Other sources give us dates for Pericles. In addition, fragmentary inscriptions on stone, which are dated, detail the expenditure on some of the sculpture adorning the temple. From these pieces of evidence, we can be confident of the dates of the architectural sculptures decorating the building (pages 54–5, 59, 62–3 and 120).

Lucian, who lived in the second century CE, gives a detailed description of various works of art including Myron's Discus-thrower (pages 32 and 35), which he distinguishes from other statues of the same subject by means of the following description '(the one) . . . who is bent over in the throwing position, is turned toward the hand that holds the discus and has the opposite knee gently flexed, like one who will straighten up after the throw' (*Philopseudes*, 18). This enables us to recognize Roman copies of this work. In addition,

Pliny (*Natural History*, 34.57–8) tells us where Myron was born and who his teacher was so that we also have a good idea of his date.

Fixed points like these are useful, but rare. When there is no such help, works that seem earlier in style are placed earlier and those that look more developed later to create what appears to be a logical sequence. Where there is no further confirmation, this chronology cannot be considered conclusive and yet this is how the history of Greek art has been built up into the deceptively clear account we tentatively accept today.

Dating Roman monuments is often easier and usually surer. Written sources often attribute certain creations to particular emperors, whose dates are documented. Often the monuments themselves bear inscriptions that indicate when they were made, for instance the Column of Trajan (pages 122 and 123).

Nevertheless many of the most beautiful and distinguished works that have survived (like the Zeus of Artemisium, for instance) are found with no information as to who made them or when. On the other hand, even though we may know the names of famous artists, we are seldom able to attach them to any extant works, whether originals or copies.

SELECTED READING

Adam, Sheila, *The Technique of Greek Sculpture in the Archaic and Classical Periods.* British School of Archaeology in Athens (Thames & Hudson, London and New York, NY, 1966)

Bluemel, Carl, *Greek Sculptors at Work* (Phaidon, London, 1955)

Boardman, John, *Greek Art* (5th edn; Thames & Hudson, London and New York, NY, 2016)

Brinkmann, Vinzenz and Raimund Wünsche, *Gods in Color: Painted Sculpture of Classical Antiquity*, exh. cat. (Stiftung Archäologie Münich, Munich, 2007)

Dunbabin, Katherine M. D., *Mosaics of Greek and Roman World* (Cambridge University Press, Cambridge, 1999)

Haynes, Denys, *The Technique of Greek Bronze Statuary* (Verlag Philipp von Zabern, Mainz/Rhein, 1992)

Kleiner, Fred, *A History of Roman Art* (2nd edn, Cengage Learning, Boston, MA, 2017)

Kousser, Rachel, *Hellenistic and Roman Ideal Sculpture: The Allure of the Classical* (Cambridge University Press, Cambridge, 2008)

Ling, Roger, *Roman Painting* (Cambridge University Press, Cambridge, 1991)

Ling, Roger, ed., *Making Classical Art: Process and Practice* (Tempus, Stroud and Charlestown, SC, 2000)

Mertens, Joan R., *How to Read Greek Vases* (Metropolitan Museum of Art, New York, NY, and Yale University Press, New Haven, CT, 2010)

Palagia, Olga, ed., *Greek Sculpture: Function, Materials, and Techniques in the Archaic and Classical Periods* (Cambridge University Press, Cambridge, 2006)

Pollitt, J. J., *The Art of Rome c.753 BC–337 AD: Sources and Documents* (Prentice Hall, Englewood Cliffs, NJ, 1966)

Pollitt, J. J., *Art in the Hellenistic Age,* (Cambridge University Press, Cambridge, 1986)

Ramage, A. and N. Ramage, *Roman Art: Romulus to Constantine* (6th edn, Pearson, London/Prentice Hall, Englewood Cliffs, NJ, 2015)

Stewart, Peter, *The Social History of Roman Art* (Cambridge University Press, Cambridge, 2006)

Walker, Susan, ed., *Ancient Faces: Mummy Portraits from Roman Egypt* (British Museum Press, London, 1997 and 2000)

Williams, Dyfri, *Greek Vases* (2nd edn, British Museum Press, London, 1999)

Woodford, Susan, *Introduction to Greek Art* (Bloomsbury, London, 2015)

Woodford, Susan, *Images of Myths in Classical Antiquity* (Cambridge University Press, Cambridge, 2003)

INDEX

Illustrations are in *italics*

Achilles 114, 159, 162, 163;
on mosaics *146, 147, 148, 149,
149*; on a sarcophagus 125, *126,
127, 127*; on vases 70, *70*, 71, *71,
72, 72*, 73, *73*, 74, *74*
Adamklissi 155, 156, *157*, 167
Agatharchos 106, 168
Agrippa 120, *120*
Ajax 70, *70*, 71, *71*, 72, *72*, 73, *73*,
74, *74*, 159, 163
allegory 116, 117
Alexander Mosaic 100, 101,
100-101, 102
Alexander the Great 83, 89, 92,
100, 101, *100-101*, 102, 105,
106, 117, 150, 160, 161, 162, 166
alloy 26
altar 76, 92, 93, 96, 119, 120, 160,
163, 166
Amazon 125, 126, *126-7*, 159
amphitheatre *142*, 143
amphora 66, 67, 72, *72*, 73, *73*, 74,
74, 75, 75
Anavyssos (kouros) 18, *18*, 19,
21, 161
Antigonids 160, 166
Aphrodite (see also Venus) 123, 159,
166; by Praxiteles (Knidia) 84,
84, 85, 87, 96; of Capua *86*, 87,
96, 123; of Melos 94, *95*, 97
Apples of the Hesperides 56, 57,
57, 117, *117*
Ara Pacis 118, 119, *118-19*, 120, 121,
155, 166
Arch of Titus 120, 121, *121*
architecture 4, 45, *46*, 47, *47*, 63,
108, 137, 161, 168
Argos 35, 37
Aristodikos 19, *19*, 21, 22, 28
Aristonothos 68, *68*, 69
Aristotle 168
Artemis 48, 166
Artemisium (Zeus of) 24, 29, *29*,
30, *30*, 31, *31*, 32, 35, 53, 163,
166, 170
Asia Minor 162, 166
Athena 40, *40*, 50, 51, 54, *54*,
57, *57*, 61, 77, *77*, 93, *93*, 94,
96, 159

Athens 18, 19, 20, 21, 27, 28, 29,
30, 31, 37, 38, 54, 59, 67, 69,
80, 159, 162, 166
Atlas (metope from Olympia)
40, 56, 57, *57*, 117
Augustan 119
Augustus (Roman emperor) *112*, 113,
114, 119, 120, 166, 168

barbarians 92, 93, 122, 124, 125,
155
Baroque 138, 139
battle 60, 148, 156, 159, 162, 166;
of Alexander and Darius 100,
101, *100-10*; of Greeks and
Amazons 125, 126, *126-7*;
of Greeks and centaurs 59,
59; of Greeks and Trojans 50,
50-51; of gods and giants 48,
48, 92, *92*, 93, *93*; of Romans
and Dacians (Romanians) 122,
122, 157
biographies 168
black-figure 69, 70, *70*, 71, 72, *72*,
73, *73*, 74, 75, 159, 166
Boscoreale 107, *107*, 132, *132*,
133, 135
Boscotrecase *128*, 136, *136*, 137, *137*
bronze 4, 23, *24*, 25, 26, 27, *26-7*,
28, 29, *29*, 30, *30*, 31, *31*, 32,
34, 35, 36, 38, 42, 88, *88*, 89,
90, 91, 160, 163
bull (metope at Olympia) 44, 57,
58, *58*, 63

centaur 59, *59*
Christianity 159, 167
Chrysaor 48, *48*, 49, *49*
coffin (sarcophagus) 125, *126-7*, 163
colonnade 61, 107, 133
colour in (wall) painting 102, 108,
117; in mosaics 101, 102, 161;
on pottery 70, 74, 162, 163; on
sculpture 33, *33*, 39, 41, 85, 121
Column of Marcus Aurelius 123,
124, *124*, 167; of Trajan 121, 122,
122, 123, *123*, 124, 143, 155,
167, 170
Commodus (Roman emperor) *110*,
117, *117*, 123, 124
Constantine 167

contrapposto 38, 43, 85, 94, 96, 114, 160, 163

copies, Roman of mosaics 105, 106; of paintings 100, 101, 102, 104, 105, 108, 130, 131, 138; of sculptures 32, 35, 41, 43, 85, 87, 88, 89, 90, 91, 97, 116, 160

Corfu 48, 55, 77, 160

corn-maiden, see Persephone

Cyclops 68, *68*, 69, 162

Dacian 121, *121*, 122, 123

Dancing Faun 88, *88*

Darius III (380–330 BCE), Persian king 101, 102, *102*

Darius the Great (550–486 BCE), Persian king 162

dating 169, 170

dedications 17, 56, 152, 153

Delphi 56, 60

Discus-thrower 32, *32*, 33, 34, *34*, 35, *35*, 166, 169

doves drinking (mosaic) 105, 106, *106*

drapery 38, 41, 42, 43, 55, 61, 85, 87, 92, 93, 97, 116, 120, 155

Earth goddess, see Gaia

Egypt (Egyptian) 8, *12* 13, 14, 15, 16, 19, 21, 23, 89, 150, 160, 166

Electra 96, *96*, 97

emperors (Roman), see Augustus, Commodus, Constantine, Marcus Aurelius, Titus and Trajan

encaustic 150, *151*, 160

Euphronios 75

Euthymides 75, *75*, 76, 80

Exekias 71, 72, *72*, 73, 74, 76

Faun, Dancing 88, *88*

female nude *64*, 77, 84, *84*, *86*, 87, 93

foreshortening 75, 76, 80, 100, 102, 160

François Vase 70

frieze 47, *47*, 60, *60–61*, 61, 62, 160; of the altar of Zeus at Pergamon *82*, 92, *92*, 93, *93*, *164–5*; of the Ara Pacis 118, 119, *118–19*, 121; of the Parthenon

61, 62, *62*, 63, *62–3*, 116, 119, 120, *120*

Gaia *93*, 94, 160

Gaul(s) 90, *90*, 91, *91*, 92, 93, 166

genre painting 108, 160

giants 48, 68, 69, *82*, *92*, 93, *93*, 94, 118, 160, 163, *165*

glass (in mosaics) 161, 162

Gorgon 48, *48*, *49*

grave marker 19, 21, 67, 154

Greco-Macedonian 89

Hadrian (Roman Emperor) 116, 167

Hebrew 152

heifer (on the Parthenon frieze) 62, *62*, 63

Hellenic 160

Hellenistic 89, 90, 93, 97, 117, 160, 161, 166

Hellenistic kingdoms 89, 90, 97, 161, 166

Hellenistic kings 117, 160, 161

Heracles *44*, 56, 57, *57*, 58, *58*, 117, 160, 161

Herakles 161

Herculaneum 131, 139, 143, 167

Hercules 117, 118, 161

Hesperides (apples of) 56, 57, *57*, 117, *117*

horse (horsemen) 37, 52, *52–3*, 53, *54*, 54, 63, *63*

Iliad 67, 68, 159

illusion (illusionistic) 65, 80, 105, 133, 134, 136, 138, 161, 162

incision 70, 71, 159

Jerusalem 121, 150, 152, 161, 167, 168

Jews 150, 152

Kleitias 70, 71

Knidia, Knidian *84*, 85, 87, 96, 159, 166, see Aphrodite by Praxiteles

Knidos 85, 159, 166

kouros *12*, 13, 18, *18*, 19, *19*, 161

Kritios Boy *10*, 20, *20*, 22, *22*, 23, 27, 28, *28*, 31, 32, 52

landscape 79, 102, 108, 109, *109*,

133, 134, *134–5*, 136, 137, *137*

Lapith (Parthenon metope) *2*, 59, *59*

Leda *84*, 85

legend (legendary) 78, 116, 125, 159, 161, 162, 163

Leonardo da Vinci 85

limestone 13, 48, 56, 154, 156

loot 121, 152, 156, 168

Lucian 169

Lycomedes 147, 148, *149*, 159, 162

Macedonia 89, 103, 160, 166

Marathon, battle of 162, 166

Marcus Aurelius (Roman emperor) 123, 124, 167

Medusa 48, *49*

menorah 121, 152, 153, *153*, 161

metope(s) 40, *46*, 47, 56, *56*, 57, *57*, 58, *58*, 59, *59*, 60, 62, 117, 155, 156, *157*, 161

Milo, Venus de 94, *95*

monuments 67, 119, 125, 127, 153, 156, 170

mosaics *98*, 100, 101, *100–1*, 102, *104*, 105, 106, *106*, *146*, 147, 148, *149*, 168

mummy portrait 150, *151*

mural painting 67, 77, 131

Myron 32, 34, 160, 169, 170

Mysteries, Villa of the 133, 134

Nikias 85, 130, 131

Odysseus 68, *68*, 108, *146*, 147, 148, *149*, 159, 162

Odyssey 67, 68, 108, 109, 162

Oinomaos 52, *52*, 53

Olympia 40, 52, 54, 56, 57, 58, 59, 62, 78, 117, 161, 166

Orpheus 78, *78*

panel paintings 87, 130, 131, 133, 138, 139, 150, 161

Parrhasios 80

Parthenon 169; frieze 61, 62, *62*, *62–3*, 63, 116, 119, 120, *120*; metopes *2*, 58, 59, *59*, 161, 166; pediment 54, *54–5*, 55, 94

Pegasus 48, *48*

Peiraikos 105

Pelops 53, *53*
Penthesilea 125, 126, *126-7*, 159
Pergamon 89, 92, 93, 96, 105, 106,
 160, 161, 163, 166
Pericles 169
Persephone 103, *103*
Perseus 48, 130, *130*, 131, *131*
Persian 92; empire 89;
 kings 101, *101*, 162;
 wars 27, 77, 89, 162, 166
perspective 80, 101, 106, 108, 132,
 139, 143, 160, 162, 168
philosophers 80, 106, 113
Philus *154*, 155
pigments 150, 160, 168
Plataea 162
Pliny 168, 169, 170
Plutarch 169
Polygnotos 77, 78, 79, 80, 169
Polykleitos 35, 36, 37, 43, 85, 87,
 113, 114, 115, 162, 166, 169
Pompeii 33, 107, 130, 131, 133, 134,
 135, 136, 138, 139, 143, 147,
 148, 167
portraits/portraiture 108, 113, 126,
 150
Poseidon 54, 55
potters 69, 163
Praxiteles 84, 85, 96, 166
Priam (king of Troy) 48, 76, *76*,
 77, 162
Prima Porta garden at Villa of Livia
 134, *134-5*; statue of Augustus
 112, 113, 119
procession(s) 61, 62, 118, 119, 120,
 121, 155
proportions 13, 19, 22, 54, 122,
 153, 163
Ptolemy (Ptolemies) 160, 166

Raphael 85, *85*
red-figure 74, *74*, 75, *75*, 76,
 76, 77, *77*, 78, *78*, 79, *79*,
 162, 166
Renaissance 85, 87, 125
river gods 53, 55

Sabina (wife of Emperor Hadrian)
 116, *116*, 167
Salamis 162, 166
sarcophagus 125, 126, *126-7*, 163

Sardis 152, 161, 162
Seleucids 160, 166
seven-branched lamp holder
 (menorah) 121, 152, 153, *153*, 161
shading 80, 150, 161
Sicyonian Treasury 56, *56*, 57, 59
signatures 69, 163
silhouette 67, 69, 71, 102, 159
single-point perspective 108
Siphnian Treasury 60, *60-61*
Sosos 105, 106
Spear-bearer 35, 36, *36*, 37, *37*,
 85, 87, 89, 113, 114, 115, 163,
 166, 169
still life 105, 106, 108
synagogue 152

tensile qualities (of bronze) 25, 31
three-dimensional 75, 80, 133,
 137, 150
Titus (Roman emperor) 115, *115*,
 120, 121, 167
tombstone 155
torso 16, 35, 37, 38, 85, 87, 94,
 114, 160, 163
Trajan (Roman emperor) 121, 122,
 123, 124, 143, 155, 156, 167, 170
Trojan/Troy 48, 76, 77, 125, 147,
 159, 162, 163

vanishing point 80
vase painting 68, 73, 77, 78, 79,
 162, 166, 169
Venus (see Aphrodite) 33, 43, 94,
 97, 116, 159; de Milo (Venus de
 Milo) 94, *95*; Genetrix (Venus
 Genetrix) 43, *43*, 97, 116
Vergina 103, 105
Vesuvius 131, 143, 167, 168
Vettii (House of the) 138, *138*, 139,
 140-41
Victory 92, 94, 123 ; image of (on
 the Column of Trajan) 123, *123*;
 of Alexander over Darius III 101,
 100-101; of Pergamenes over
 Gauls 92
Villa of the Mysteries 133, 134
Villa of Livia (at Prima Porta) 134
Vitruvius 80, 168

white-ground 80, *80*, *81*, 163

Zeus 56, 57, 58, 94, 96 161, 163;
 of Artemisium *24*, 29, *29*, 30,
 30, 31, *31*, 32, 35, 53 163, 166,
 170; on Great Altar at Pergamon
 92, *92*, 93, *93*, 94, 96, 163, *164*
Zeuxis 80

PICTURE ACKNOWLEDGEMENTS

a above, **b** below, **c** centre, **l** left, **r** right

2 British Museum, London; **4–5** DEA/L.Pedicini/Getty Images; **10** Acropolis Museum, Athens; **12r** The Metropolitan Museum of Art, New York, NY; **12l** British Museum, London; **14–15** Sue Bird; **18l** Peter Horee/Alamy Stock Photo; **18r** Marie Mauzy/Scala, Florence; **19l** The Metropolitan Museum of Art, New York, NY; **19r** Adam Eastland/Alamy Stock Photo; **20** Acropolis Museum, Athens; **22** Marie Mauzy/Scala, Florence; **23** The Metropolitan Museum of Art, New York, NY; **24** Leemage/Getty Images; **26–7** Sue Bird; **28, 29, 30** Leemage/Getty Images; **31** Susan Woodford; **32** B. O'Kane/Alamy Stock Photo; **33** Melvyn Longhurst/Alamy Stock Photo; **35** Susan Woodford; **36** Adam Eastland/Alamy Stock Photo; **37la and lc** Susan Woodford; **37b** National Archaeological Museum, Athens; **39l** Photo Scala, Florence/bpk, Bildagentur für Kunst, Kultur und Geschichte, Berlin; **39r** De Agostini/Getty Images; **40** Nicola De Carlo/Alamy Stock Photo; **43** Erich Lessing/akg-images; **44** Nicola De Carlo/Alamy Stock Photo; **46–7** Sue Bird; **49** DEA/G. Dagli Orti/Getty Images; **50–51a** Vanni Archive/Getty Images; **50–51b** Sue Bird; **52–3a** Vasilis Ververidis/123RF; **52b** Sue Bird; **54–55** Bibliothèque Nationale de France, Paris; **56** DEA/G. Nimatallah/Getty Images; **57, 58** Nicola De Carlo/Alamy Stock Photo; **59** British Museum, London; **60–61** De Agostini/Getty Images; **62–3, 62b** British Museum, London; **64** Interfoto/Alamy Stock Photo; **66** Leemage/Getty Images; **68** DEA/G. Dagli Orti/Getty Images; **70** Heritage Image Partnership/Alamy Stock Photo; **72** Photo Scala, Florence; **73, 74** Museum of Fine Arts, Boston/Scala, Florence; **75** Staatliche Antikensammlungen und Glyptothek, Munich; **76** Photo Scala, Florence; **77** Interfoto/Alamy Stock Photo; **78** Photo Scala, Florence/bpk, Bildagentur für Kunst, Kultur und Geschichte, Berlin; **79** DEA/G. Dagli Orti/Getty Images; **80** De Agostini/Getty Images; **81** DEA/G. Dagli Orti/Getty Images; **82** PHAS/Universal Images Group/Getty Images; **84l** Nimatallah/akg-images; **84r** Royal Collection/© Her Majesty Queen Elizabeth II 2019; **86** Photo Saliko/CC-BY-3.0; **88** Photo Scala, Florence; **90** Simon Rawley/Alamy Stock Photo; **91** Shirlee Klasson/Alamy Stock Photo; **92, 93** PHAS/Universal Images Group/Getty Images; **95** Musée du Louvre, Dist. RMN-Grand Palais/Thierry Olivier; **96** Leemage/Getty Images; **98** Azoor Photo Collection/Alamy Stock Photo; **100–101** National Archaeological Museum, Naples; **103** Art Collection 2/Alamy Stock Photo; **104** Azoor Photo Collection/Alamy Stock Photo; **106** DEA/G. Dagli Orti/Getty Images; **107** The Metropolitan Museum of Art, New York, NY; **109** De Agostini Picture Library/akg-images; **110** Araldo da Luca/Getty Images; **112** Musei Vaticani, Rome; **115** Granger Historical Picture Archive/Alamy Stock Photo; **116** Carole Raddato; **117** Araldo da Luca/Getty Images; **118–19** Andrea Jemolo/Electa/Mondadori Portfolio/Getty Images; **120** Musée du Louvre, Paris; **121** Matthew Ragen/123RF; **122** Mircea Costina/Alamy Stock Photo; **123** akg-images; **124** Stefano Venturini/REDA & Co./Alamy Stock Photo; **126–7** Paul Williams/Alamy Stock Photo; **128** The Metropolitan Museum of Art, New York, NY; **130** DEA/G. Nimatallah/Getty Images; **131** Azoor Photo Collection/Alamy Stock Photo; **132** The Metropolitan Museum of Art, New York, NY; **133** Kristyna Henkeová/123RF; **134–5** Eric Vandeville/akg-images; **136, 137** The Metropolitan Museum of Art, New York, NY; **138** David Hiser/National Geographic Image Collection/Alamy Stock Photo; **139** Photo Scala, Florence – courtesy of the Ministero Beni e Att. Culturali e del Turismo; **140–41** Eric Vandeville/akg-images; **142** Adam Eastland/Alamy Stock Photo; **144** British Museum, London; **146** Richard Purkiss/akg-images; **149** Balfore Archive Images/Alamy Stock Photo; **151** British Museum, London; **152** Sue Bird; **153** Archaeological Exploration of Sardis/President and Fellows of Harvard College; **154l** Gloucester Museums Service; **154r, 156** Sue Bird; **157** Susan Woodford **164–5** PHAS/Universal Images Group/Getty Images

\-

For Léo, Felix And Mia
To bring the past to the future

\-

Greek and Roman Art © 2020
Thames & Hudson Ltd, London
Text © 2020 Susan Woodford

Design by April
Edited by Caroline Brooke Johnson
Picture research by Sally Nicholls

First published in 2020 in the
United States by Thames & Hudson
Inc., 500 Fifth Avenue, New York,
New York 10110

www.thamesandhudsonusa.com

Library of Congress Control
Number 2019947729
ISBN 978-0-500-29525-0

Printed and bound in China by
Toppan Leefung Printing Ltd

Front cover: Perseus and Andromeda, from Pompeii, near Naples, probably a copy after a painting by Nikias, c.340 BCE (detail from page 130). National Archaeological Museum, Naples

Title page: Lapith fighting a centaur, metope from the Parthenon in Athens, c.447–438 BCE (detail from page 59). British Museum, London

Pages 6–7 Garden and birds fresco, 1st century CE, Casa del Bracciale d'Oro (House of the Golden Bracelet), Pompeii, near Naples, 200 x 275.3 cm (78¾ x 108⅜ in.)

Chapter openers: page 10 Kritios Boy, c.480 BCE (detail from page 20). Acropolis Museum, Athens **page 24** Zeus of Artemisium, c.460 BCE (detail from page 30). National Archaeological Museum, Athens; **page 44** Heracles struggling with the Cretan bull, metope from the Temple Zeus at Olympia, c.460 BCE (detail from page 58). Louvre, Paris; **page 64** The Sack of Troy, c.500–490 BCE (detail from page 77). National Archaeological Museum, Naples; **page 82** Giant, part of the frieze of the Great Altar, Pergamon, c.180–150 BCE (detail from page 93). Pergamon Museum, State Museums of Berlin, Berlin; **page 98** Street musicians, copy signed by Dioskourides of Samos as mosaicist, c.100 BCE (detail from page 104). National Archaeological Museum, Naples; **page 110** Commodus as Hercules, late 2nd century CE (detail from page 117). Capitoline Museums, Rome; **page 128** Small floating landscape on Roman wall painting, from the imperial villa, Boscotrecase, near Naples, late 1st century BCE (detail from page 136). Metropolitan Museum of Art, New York, NY; **page 144** Mummy portrait, c.160–70 CE (detail from page 151). British Museum, London

Pages 164–5 Zeus battles giants, part of the frieze of the Great Altar, Pergamon, c.180–150 BCE (detail from page 92). Pergamon Museum, State Museums of Berlin, Berlin